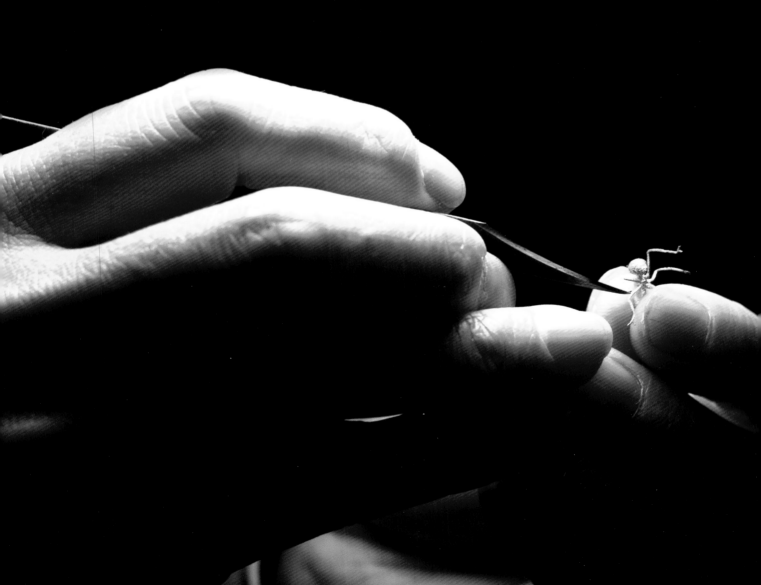

吳卿將其幼年觀察大自然

石間、花下、豆棚、瓜架，萬物榮生的世界——呈現；

此以見其明察秋毫之末，於是遂在雕刀移動間，

傳遞了物外之趣。

前台北故宮博物院院長

（節錄自1997年〈吳卿金雕藝術〉圖冊前言）

With his keen observations of nature seamlessly transformed into outstanding works of art, Wu Ching has, through the precise modulation of pressures with wich he applies his tools, offere the viewer a rare opportunity to let the min soar free from the material world.

Chin Hsiao-Yi

Ex-director
Tapei National Palace Museum

quoted from "Foreword" in the catalogue, The Gold Sculptures of Wu Ching (1997)

碾磨雕刻眼中是金，

手上飛屑遺落的也是金，

但吳卿心中，卻不是金，而是一本本修行的經，

雕刻的不紛擾、不雜礙，如同面佛而修行，

倦極、累極時稍事打坐，立刻又神回心轉，意會情適；

沈香繚繞在動心忍性的思辨空間，

下了千百回苦工夫，琢磨掉千百日好光陰的藝術創作，

他的切雕已是另一番心情。

星雲

（節錄自1997年〈吳卿金雕藝術〉圖冊中「金雕‧精雕‧經典之雕」一文）

The material he shapes is gold, and the residue on his hands is gold . But in his heart, there is not gold but self-cultivation. Sculpting, free from distraction and hindrances, is like cultivating oneself in direct contact with the Buddha. When exhausted, a brief period of meditation restores the spirit. Incense swirls around the space he reserves for inspired but patient reflection. With much hardship and over a long period of time, he has refined his creative works of art until his sculpting has now reached a higher state.

Hsing Yun
Buddhist Master

quoted from "The Sculptures of Gold, of Sophistication, of Classic Profundity" in the catalogues, The Gold Sculptures of Wu Ching (1997)

金雕細琢—吳卿金雕藝術特展

吳卿先生主要的作品之一，是一個以他自身為造型的人頭雕塑，臉上眼睛張開，嘴唇微揚，頭頂迸開，化為群蝶徐徐的往上飛舞。這件作品是他悟入寧靜，體驗到內心如泉源般湧出的喜悅而創作的，故名「法喜」。他說：「頭上的蝴蝶已不是蝴蝶，早已轉化成真、善、美、慧的境界。」吳卿以鬼斧神工之雕技，結合自身在心地上的修煉，創作出一件件撼動人心的作品，可謂藝術創作的最高境界。

吳卿青少年時期無師自學，專攻木雕，憑著敏銳的觀察力與專注一致的心思，以精湛刀法，還原微觀大千世界的風貌。後為尋求自我突破，他選擇用高難度、高成本的純黃金作雕刻材質，在一遍遍的嘗試之後，終於突破金雕藝術的極限之處，創造出屬於「吳卿品牌」的作品特色：精緻、細密與薄透，堪稱世界一絕。

吳卿以藝術創作當作生命的修持，學佛修禪數十年的他，了悟萬物為眾緣和合而成，因此廣結善緣，在1997年，由國際佛光會中華總會主辦，於臺北國父紀念館中山畫廊發表「吳卿金雕展」，以門票收入捐助佛光大學，作為建校基金。

《大乘本生心地觀經》卷第五記載：「唯有法喜禪悅食，乃是聖賢所食者。」吳卿以法喜禪悅為食，化為創作的能源，作品自然充滿禪機，無限法喜。茲逢佛陀紀念館落成與壬辰新春喜慶之日，特邀吳卿先生以其法喜之作共襄盛舉，祈願與會者法喜安康，龍天護佑。

<div align="right">佛陀紀念館‧館方序</div>

Works in Gold - Exhibition of Gold Sculptures by Wu Ching

One of Wu Ching's major works is the sculpture of a head molded after his own. With eyes wide open and lips in a slight smile, the cracked open head emits a group of butterflies that are slowly fluttering out. Created as a result of his realization of tranquility and his experience of joy erupting from the fountainhead of his inner mind, this piece is entitled The Bliss of the Dharma. According to him, "The butterflies are no longer butterflies; they have long been transformed into the realm of truth, goodness, beauty, and wisdom." Integrating extraordinary craftsmanship with his own spiritual cultivation, Wu Ching has created piece after piece of moving artwork. It can be said that he has reached the highest realm of artistic creativity.

Having taught himself wood carving during his youth, Wu Ching draws upon his keen powers of observation, unshakable concentration, and exquisite carving skills to create reproductions of the microscopic world. Seeking to transcend himself, he chose to work with pure gold; a material that is both costly and extremely difficult to work with. After many attempts and much hard work, he was able to break through the boundaries of the art of gold sculpture to establish a "Wu Ching trademark" whereby his exceptional creations are characterized by: exquisiteness, meticulous detail, and thin transparency.

Viewing artistic creation as a form of cultivation, and having practiced Zen Buddhism for many years, Wu Ching is aware that all things in the world are formed by their conditions, and he believes in broadly developing good affinities. As such, all proceeds from the Exhibition of Gold Sculptures by Wu Ching that was sponsored by BLIA Chughua and held at National Dr. Sun Yat-sen Memorial Hall in 1997 were donated to the founding of Fo Guang University.

According to the fifth fascicle of the Great Vehicle Sutra of Contemplation of the Mind Ground in the Buddha's Life, "The only form of nourishment required by the Sages is the nourishment of meditative bliss." Transforming this nourishment of meditative bliss into the energy source of his creativity, Wu Ching's works are naturally filled with the spirit of Zen and the boundless bliss of the Dharma. In celebration of the completion of the Buddha Memorial Center, which happens on the 100th anniversary of the Republic of China, a special invitation has been extended to Wu Ching to come exhibit his creations. We wish those who join us on this joyful occasion safety and health as well as heavenly blessings and protection.

Fo Guang Shan Buddha Memorial Center. Museum sequence

目次

精質焠鍊　精藝傳神

　　吳卿是國內罕見的多面向藝術工作者，不僅是一位執於金雕，而且更是擅於木雕的藝術家；同時亦是精於傳統，強於創新，專於前衛，攻於當代的多元跨域創作思惟者。在長達二十五年的創作生涯，不僅播下一棵棵的木雕藝術種子，使其逐步開花結穗，並且開創一件件的金雕藝術精品，使其蔚為林蔭大道，誠為國內近年開拓精緻藝術創作的佼佼者，更是開發文化創意產業的打造者。

　　吳卿之作，若以木雕言，達有百件之譜，大略觀之，有四大類項，即螞蟻系列、禪意系列、生態系列、生死系列。

　　螞蟻者，是其首創之作，亦是成名標幟。此系列源自螞蟻自然生態屬性本能的肉眼觀察，賦予心眼微觀細靡境地的刀刻精進技法呈顯，讓人直覺讚嘆那不可思議的精藝火候境地。像那花費4015小時完成的10呎〈搬運飯粒的一群螞蟻〉大作即是。

　　禪意者，是其面對自我省察，應現自然心觀的自我風格形成與自主創作語彙的開創奠定。其代表〈禪〉、〈無礙〉等，已擺脫源自自然眼觀的創藝境地，直接蛻變潛藏心靈底韻的抽象意念；並且賦予徹底簡潔洗練，又精簡意賅的造型思惟之美。

　　生態者，即其面對大地生態異變，尤在污染橫流大地萬物逐步走入滅絕的不忍與吶喊之際，開創了一件件獨步匠心的命題。例如〈我需要泥土〉一作，以極其寓意對比手法，即樹根穿透象徵污染源玻璃瓶制限，使人人知解進達「生存有淨土，生命能昇華」的自然法則生命觀。

　　生死者，即超越一切心縛，有形界域，回歸生命本源，還原藝術本質的深層境地探索，以企達一道無礙無阻的自我永恆價值發現與衝創。例如，〈塵緣〉、〈緣生妙有〉、〈情為何物〉等。當然此四大系列生成創變，再造顛峰，其實即在於其修行的真實本源生命力上。

　　吳卿之修，在於誠實之心與自然之情。不論哪一系列？何者題材？吳卿皆以最虔敬的心境，最直覺的儀式，洗禮每一創作對象。其儀式不為他，就是直接的眼觀、手觸、心動，進而長時間的生蓄涵養，以盡徹底知解，著手創作。如螞蟻系列，先一一蓄養，待知其自然習性，色澤蟻種，肢體本能，甚而食物嗜好等，再行雕作。故其作栩栩如生，精彩絕倫。像那精準雕出四隻螞蟻垂直90度地「合力推蟲」搬運壁虎而上的一幕，不是費心用功細靡觀察螞蟻的自然生態與其大千世界，一般人是發現不到此道題材，也創作不出這麼震憾心靈的絕妙之作。再者，像那生死系列的〈情為何物〉、〈禪，坐？〉所表現的骷髏骨架，是當年花四萬元買的一副死人骨頭，且製成玻璃纖維並加以精研摸索，請教專人解析後，始著手雕之。這樣誠實禮敬之心，其實即在於他一切追求自然生命源本，觀察自然原生習性狀態的藝術創作修行上。

　　吳卿之藝，即在於自然本源形體大相的精緻闡發，抽象意念精湛語彙的體現昇華，進而毅然決力以心志徹底的驅使掌握，作精彩刀法雕藝的至性完美表達，直至作品進達精質傳神的「大相」境地。因而，源自自然物象的原生價值創發，成為發現自我造型語彙的最重要基礎來源，亦是曝現自身思惟辯證的最根本核心檢視。〈昇華〉一作，細細觀之，即可明見。其作造型語彙簡約素樸，僅一坨圓體，延伸一線，蜻蜓其上。整體言，簡潔清新，落落大方。然而潛藏無窮。由上觀之，展翅蜻蜓，竭盡拉長體驅，徐徐轉動而下，直至無盡深淵底境下的天際一線之間，這時底境之處一下呈現一坨渾圓球體，其上一道道韻律旋轉水紋，令人感覺有如浸潤在一座生生不息，湧現無盡生命水源的母體胎衣之中。這樣簡潔有勁的渾圓體，由下觀之，正如一個圓球母體浸於水中正孕育著蜻蜓的幼蟲子孑於內，欲破大繭飛身而出。換言之，球體有如人間母體的原形，代表新生命的孕育，而母體胎衣的螺旋漸漸轉動升起，象徵新希望的懷抱，順著無盡上昇的一線天，通過自我超脫的束縛與藩籬，開展一道道嶄新的自我期許與昇華。這樣簡潔素淨的〈昇華〉語彙，正蘊藏著作者精緻傳達的不可思惟辯證，更綻放著精彩一線天的「大相」境地之美。

　　吳卿之美，在於其心神毅力與作品大相，渾然一體的至善至美境地之發掘。每一作品大相，有著日夜嘔心，琢磨焠鍊的至真至情修行大境。真實的走進自然叢林中，真誠的走出自我生命來，是其人生精雕藝術的第一道美學，讓人見其自然化現的簡約精髓之美。尊敬的走進禪修叢林中，謙遜的走出禪境生命來，是其精藝雕刻的第二道美學，讓人見識禪修大化的精質情境之美。無懼的走進生死叢林中，無畏的走出死生生命來，是其大雕藝術的第三道正心美學，讓人見證圓滿實境之美。道道之美，層層之學，不僅建構起吳卿的視覺真賞，刀藝真情，而且創生出吳卿的思辯真見，實踐真諦。故其修行，在於作品大相的真實情境生命探索，更在形式風格的真情原創生命鑑定。〈禪〉之一作，或〈無礙〉一作，細細品賞，確確傾讀，即可知之，更可檢視。極緻抽象意念，化現不可思議的命題開發與精藝呈顯，是其最美的大美之境。然其內蘊深藏浸潤的殊勝「進出之美」大學，盡在獨特慧心凝想的造型語彙散發綻放中。故綜而觀之，所謂的吳卿美學，即在於造型語彙上，簡約主義之美的思惟辯證賦予；在抽象意念上，純淨主義之美的心境鑑識剔鍊；實現境地上，精質主義之美的焠鍊傳神真顯。

　　當然，吳卿精於自然之道，入於心眼之手的不可思議境地創造美學，是其心靈永不竭息的創生能源，更是終生精進奉行的大道圭臬。

國立台北藝術大學 文化資源學院院長

林保堯

2003.03.15

2

Extracting the Refined, Imparting the Spiritual

Wu Ching is one of the rare multi-faceted artists in Taiwan who excel in the art of gold and wood carving. Grounded in tradition, his creative strengths and avant-garde perspective enable him to excel as a contemporary practitioner of fine art who can cross the boundaries between different disciplines. During the twenty-five years of his creative life, he has not only sown the seed for wood carving, and helped it bloom, but has also explored the different possibilities of gold work and brought the refined art to its height. Being a forerunner in art, he added a cultural dimension to his works.

Wu Ching has created more than 100 wood carvings, and they can be broadly divided into four major series, namely, the Ants Series, the Zen Series, the Ecology Series, and the Life and Death Series.

The Ants Series started his creative career and established his reputation as a professional artist. Inspired by his close observation of the ecological life of ants, Wu Ching created works with unsurpassed technical proficiency. The result is a stunning verisimilitude, marked by his attentiveness to microscopic detail. The ten-feet tall "Rice-Carrying Ants," a masterpiece said to have taken the artist 4015 working hours to complete, is a perfect example.

The works in the Zen Series are both self-reflective and reflect on nature. The personal characteristics and new vocabulary of forms are central to this series. Representative works, such as "Zen" and "Unhindered," transcend physical observations of natural objects; instead, they contain the soul of abstract ideas buried beneath. They express a refined aesthetic characterized by simplicity and precision.

Witnessing the ecological mutation brought about by pollution, a crisis in which living creatures face possible annihilation, Wu Ching began his unique Ecology Series. In the work, "I

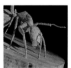

Need Soil," roots of a tree struggle out of the limited space from a glass vessel, which symbolizes the source of pollution. With this metaphoric juxtaposition, the artist reminds us of a natural law of life: "With a clean piece of land, life can be sublime."

Life and death transcend spiritual bonds and physical boundaries; the works in Wu Ching's final series return to the very origin of existence and restore the nature of art. "Mundane Affinity," "Mystery of Life," and "What Is Love" illustrate the essence of this series. Because of the artist's cultivation and practice, the works in this series mark the height of his creative powers.

The art of Wu Ching features a candid and naturalistic frankness. In all four series, regardless of the materials used, Wu Ching baptizes each individual work with devout piety and intuitive ritual. That ritual includes directly seeing, touching, and feeling, which with prolonged fermentation and cultivation lead to a harmonious understanding that is later transplanted into each work. While working on the Ant Series, for example, Wu Ching actually kept an ant colony in order to study the ants' ecological cycles, physical instincts, and even their dietary habits. The result has an extraordinary precision and vitality. Without this kind of microscopic observation, it would have been impossible to bring to life with such strength and intensity an image of four ants moving vertically up a gecko, nor would it be capable of touching the souls of this universe. Works in the Zen Series such as "What Is Love" and "Zen, Meditation?" went through a similar creative process. When undertaking these works, Wu Ching spent forty thousands dollars for a human skeleton, remade it in glass fiber in order to study its details, and later consulted experts for an anatomical analysis. With such piety and humility he seeks the origin of life in all of his works.

The essence of Wu Ching's art is in the way he imbues concrete natural objects with an abstract vocabulary of art forms. In his creative process, his determination is condensed into a will of

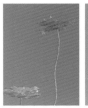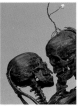

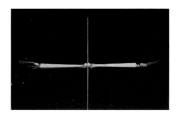

steel that enables him to modulate his tools with perfect proficiency until his works become an organic whole. The belief that the value of every creature comes from its nature is at the core of Wu Ching's dialectical expression. "Sublimation" testifies to this. The shape of the work features simplicity and restraint. Based upon an orb, a line swirls upward and is topped by a dragonfly. Without the burden of sophisticated designs, it demonstrates how the infinite can be accommodated within the finite. Viewed from above, the dragonfly extends its torso to the extreme, and it slowly twirls down until the unknown abyss and the skyline become indistinguishable. The orb at the bottom with spiral ripplets presents the feeling of being immersed in an everlasting source of life; it is reminiscent of the womb of a mother. Viewed from the bottom, the cavity is like a womb accommodating and enveloping nymphs in their metamorphoses, which are ready to burst into new life. In other words, the orb, the prototype of the womb/mother, represents the origin of life. With upward spirals, the self, liberated from bonds and boundaries, greets a new life of hope and sublimation. "Sublimation," with its unprecedented straightforwardness, blossoms with the beauty of an organic whole.

The beauty of Wu Ching's work is the consummation and integration of the spiritual and the material, seamlessly combined and elevated to the realm of goodness and beauty. The perfection of each of his works embodies his indefatigable effort and infinite pains in carving and polishing. To fully appreciate his aesthetics, we must understand the three philosophical lessons that serve as a backbone to his artistic genius. First is the need to walk honestly into the realm of nature and then come out with the same honesty. Second, to advance into the spirit of Zen with piety and break into a life of Zen with humility is required. Third is the necessity to stride fearlessly toward the realm of death and live a life of courage. These three lessons construct the aesthetics of Wu Ching and witness the perfection of his art, while at the same time formulate his dialectical practices. Examining the works of Wu Ching with attentiveness, we also catch glimpses of his philosophical inner self. A keen appreciation of works such as "Zen" and "Unhindered" testify to a unique aesthetic experience. That abstract concepts can be captured and presented with incredi-

ble precision and vivacity is one of the greatest achievements of Wu Ching. The freedom to move in and out of the soul and the physicality of objects allows the artist to transform his perception with refreshing design. All in all, based upon a new visual vocabulary and creative art forms, and cultivated by his stylistic restraint and simplicity, the objects d'art of Wu Ching transmit an abstract message and at the same time bestow a stunning experience for the eye.

Without a doubt, Wu Ching, who has been nourished by nature and has an unsurpassed mastery of his tools, is endowed with a creative fountain which does not run dry. His aesthetics and philosophy will serve as a beacon continuing to brighten the life of his art.

Lin, pao-yao

Dean
Faculty of Culture Resources
Taipei National University of the Arts

吳卿金雕藝術精覽

The Best of Wu Ching's Gold Sculptures

攝影／林日山　Photograph by Lin Ryh-Shen

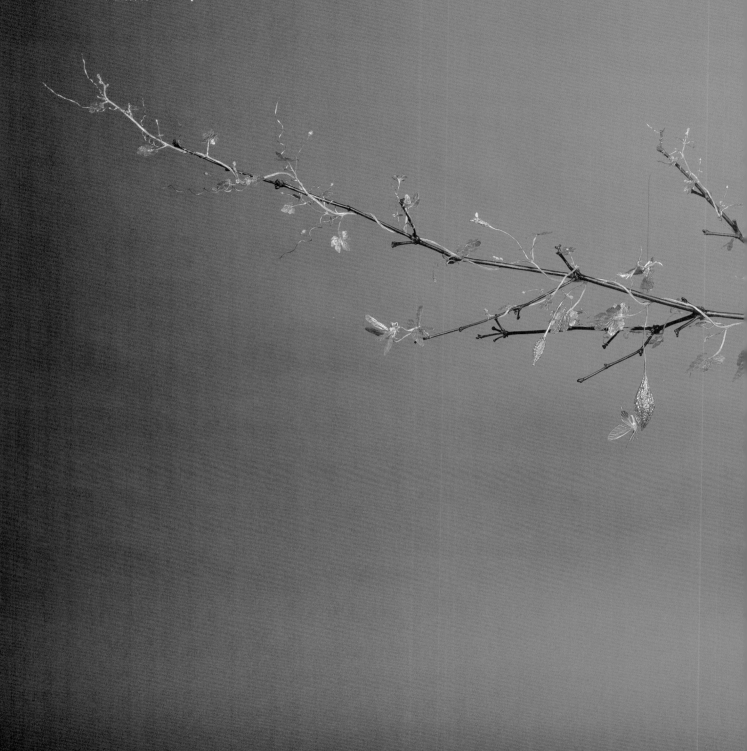
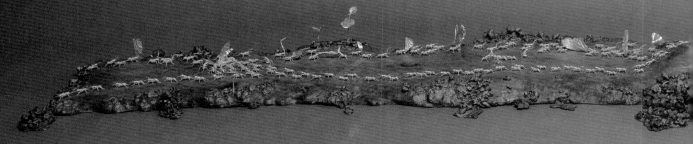

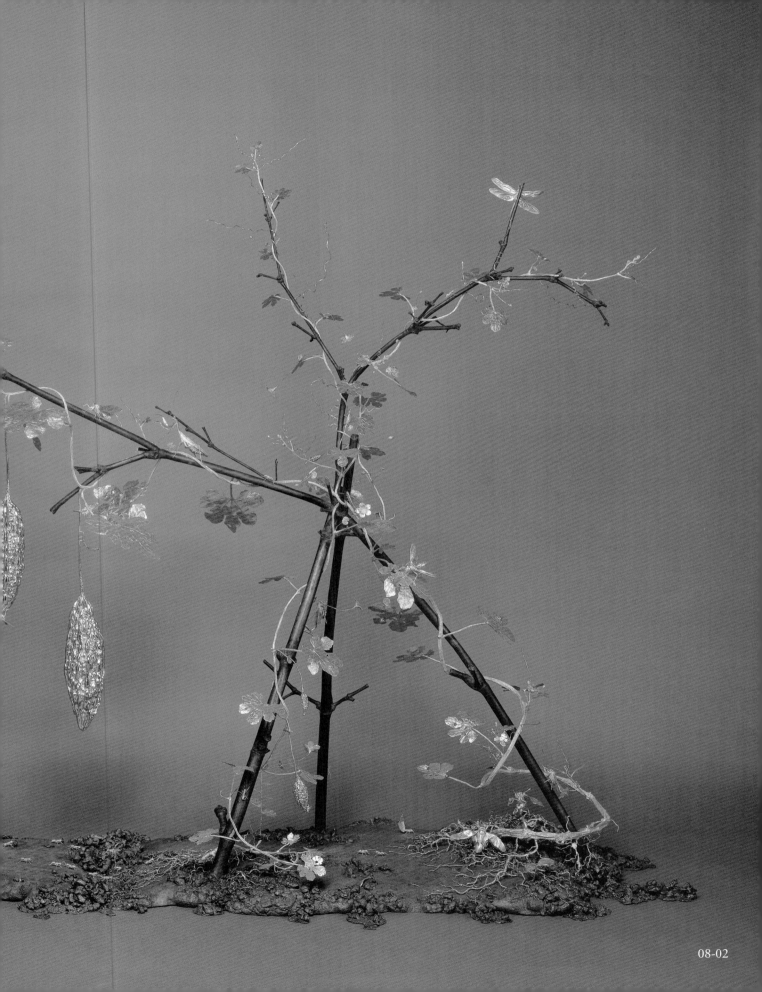

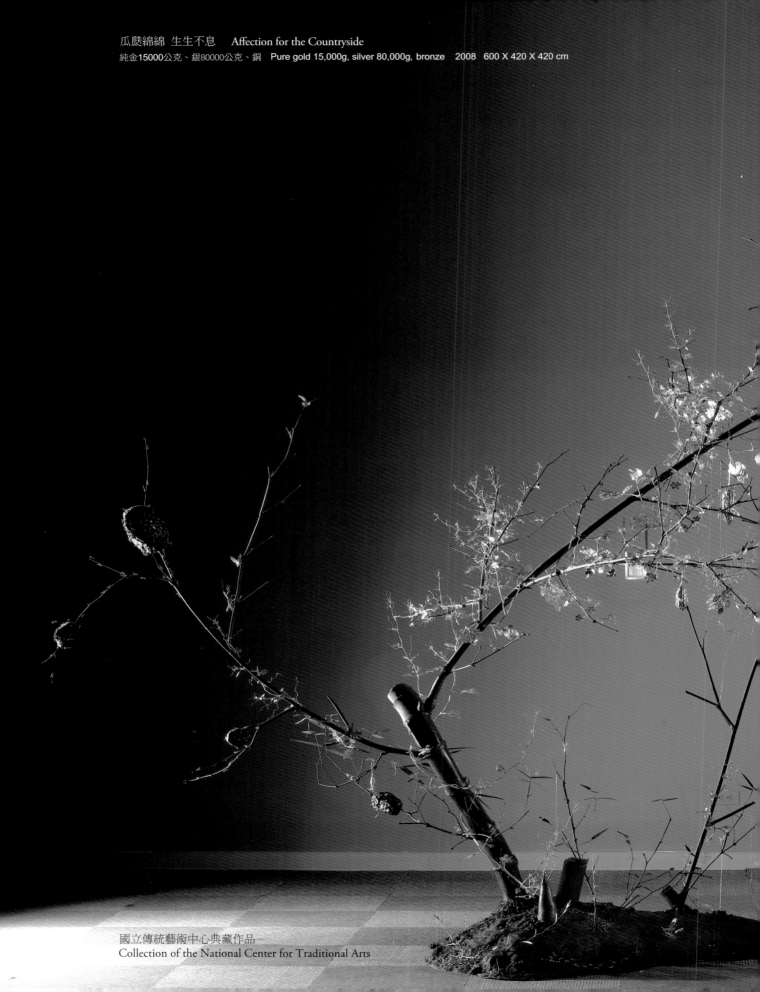

瓜瓞綿綿 生生不息　Affection for the Countryside
純金15000公克、銀80000公克、銅　Pure gold 15,000g, silver 80,000g, bronze　2008　600 X 420 X 420 cm

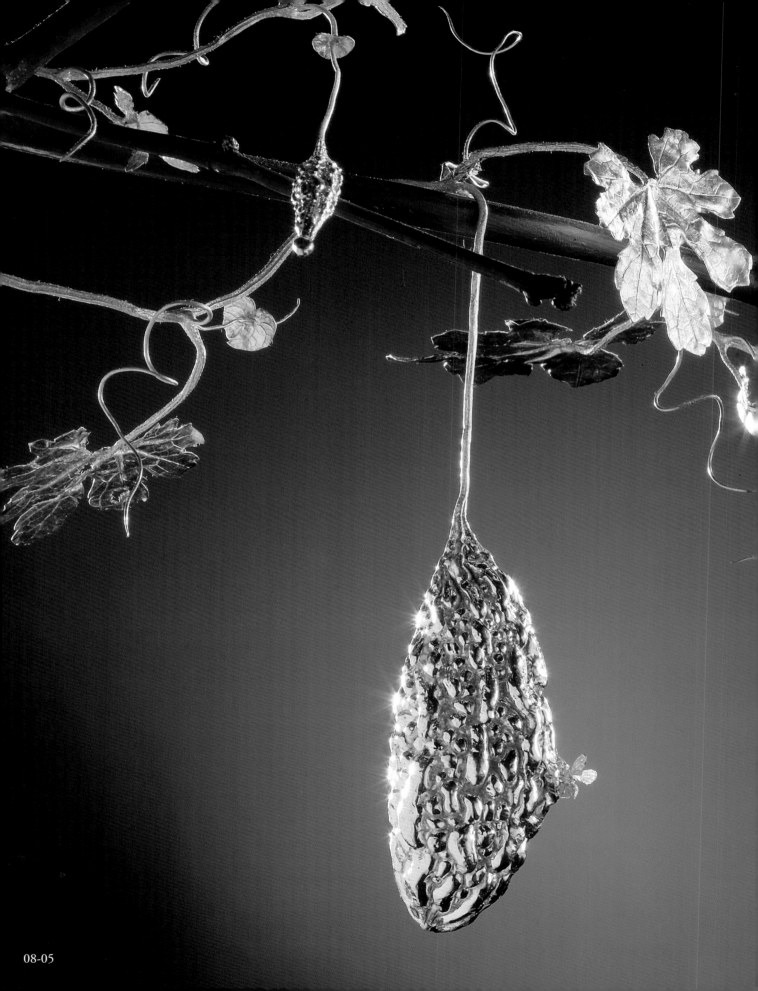

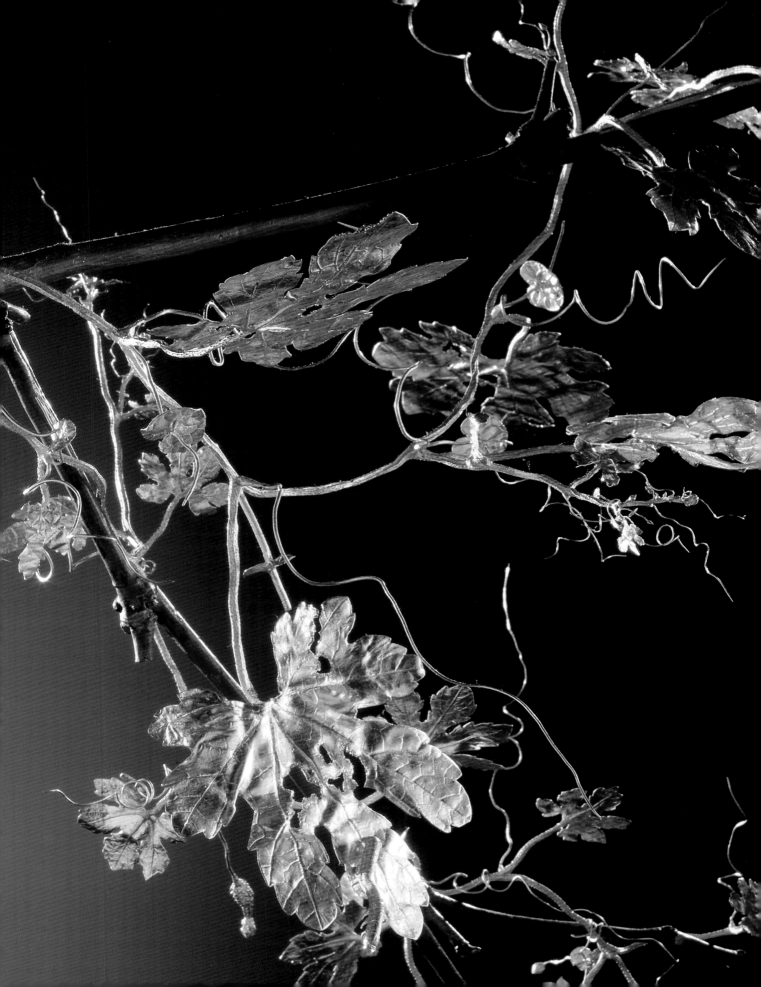

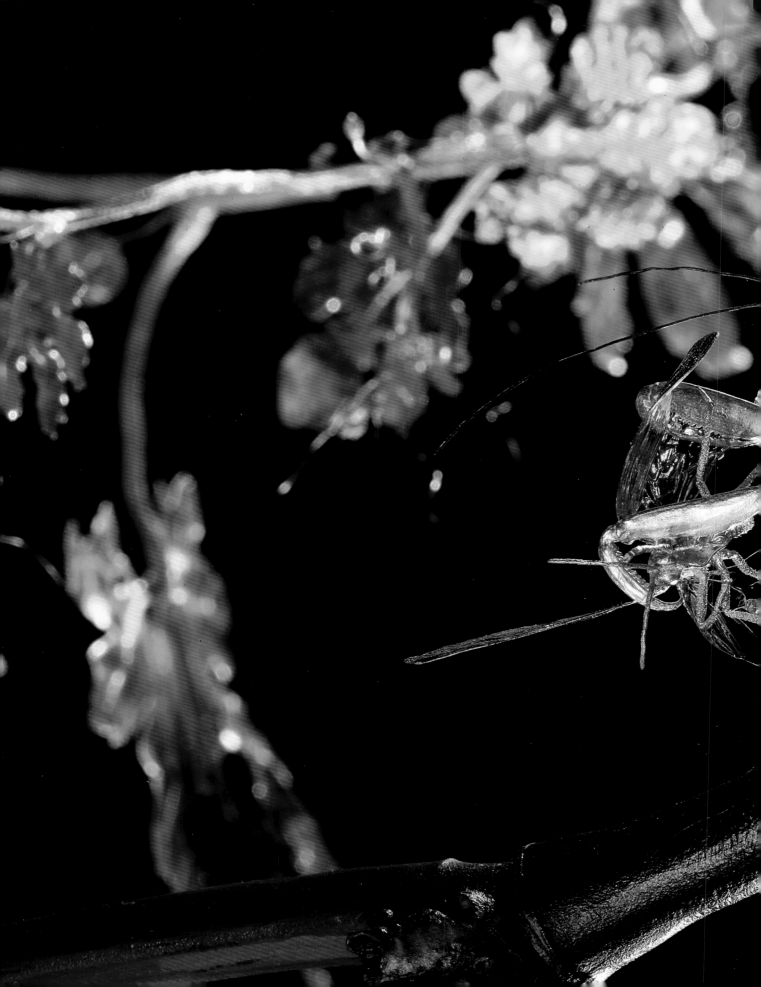

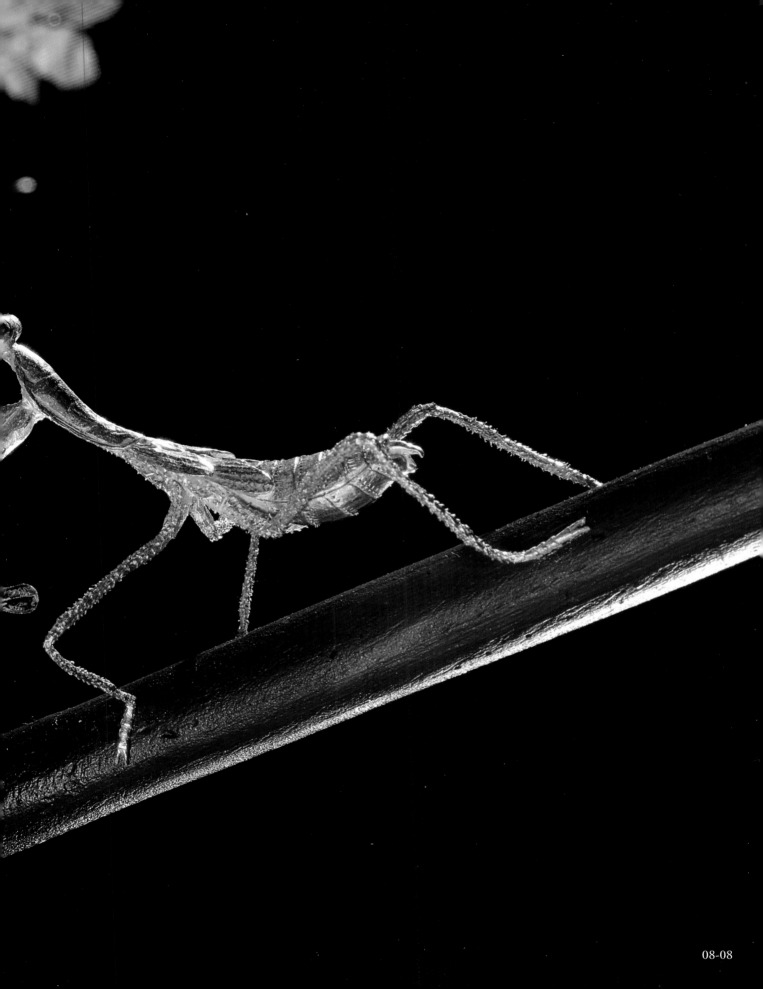

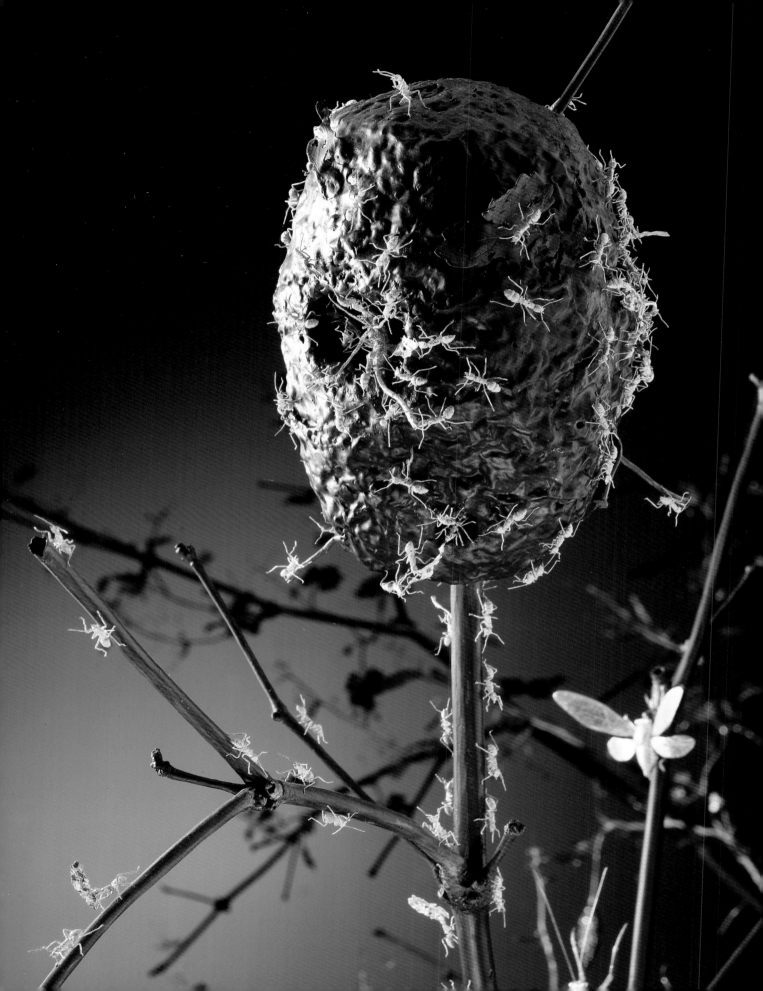

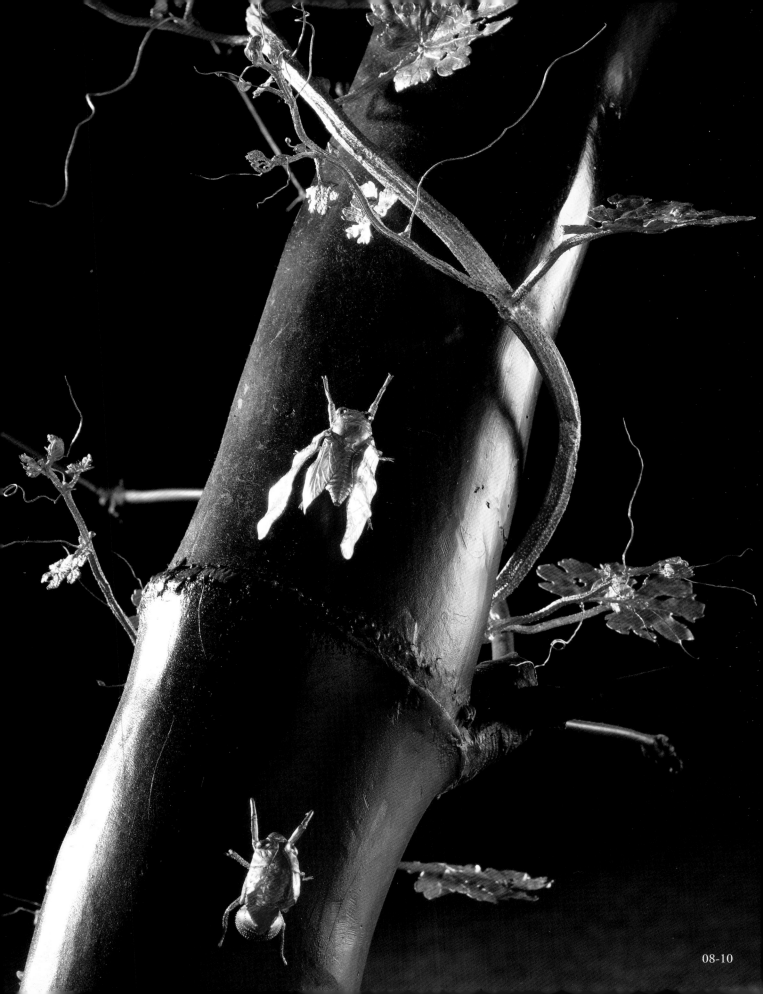

大翼戰船 （春秋時期東吳戰船）　　Da Yi Fighting boat The spring & Autumn period

純金3,000公克　Pure gold 3,000g,　2010　43 X 13 X 16 cm

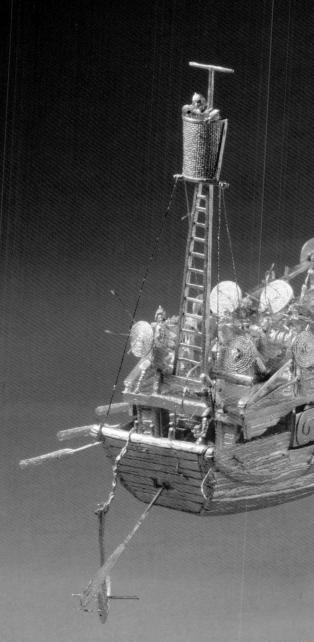

中國航海博物館典藏　Collection of the China Maritime Museum

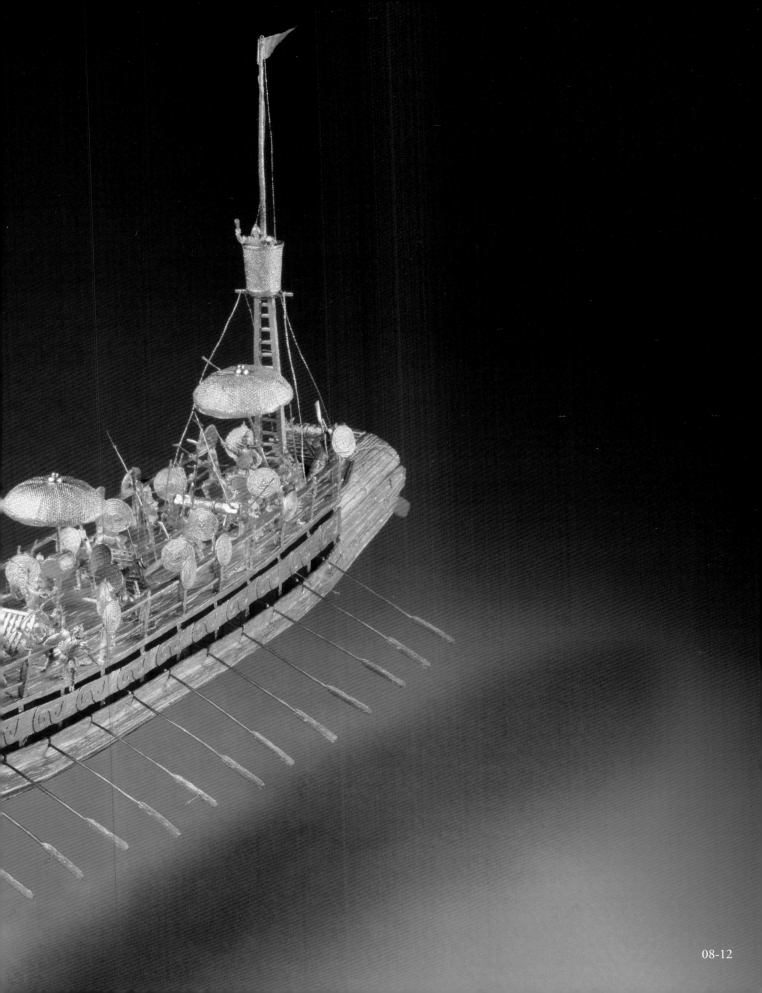

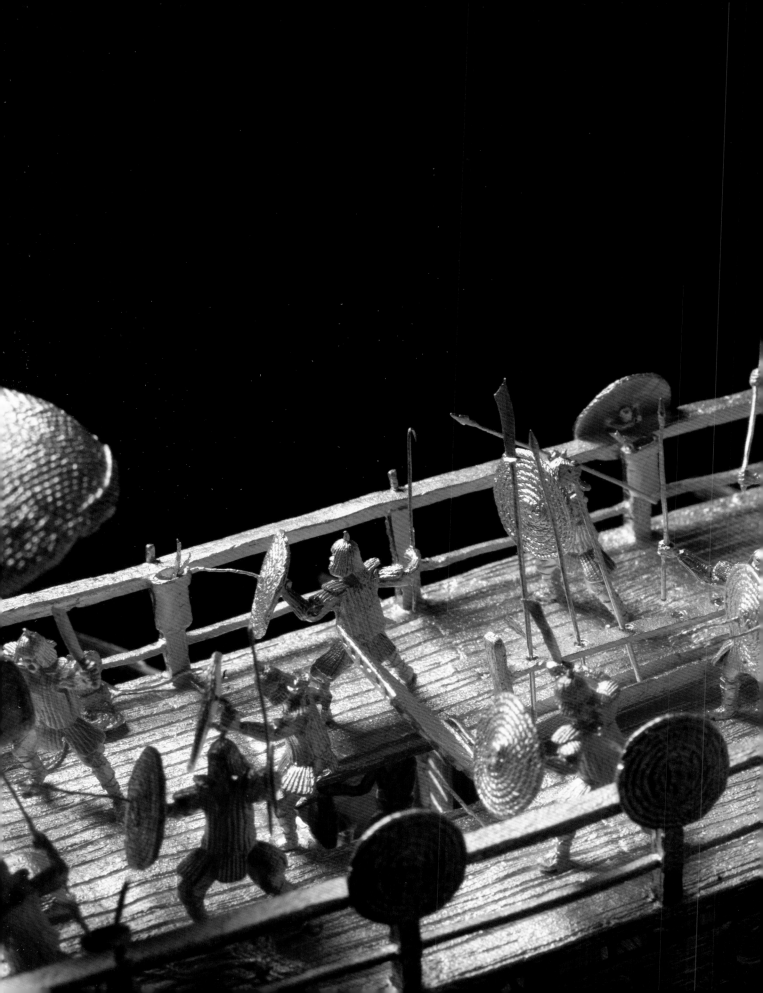

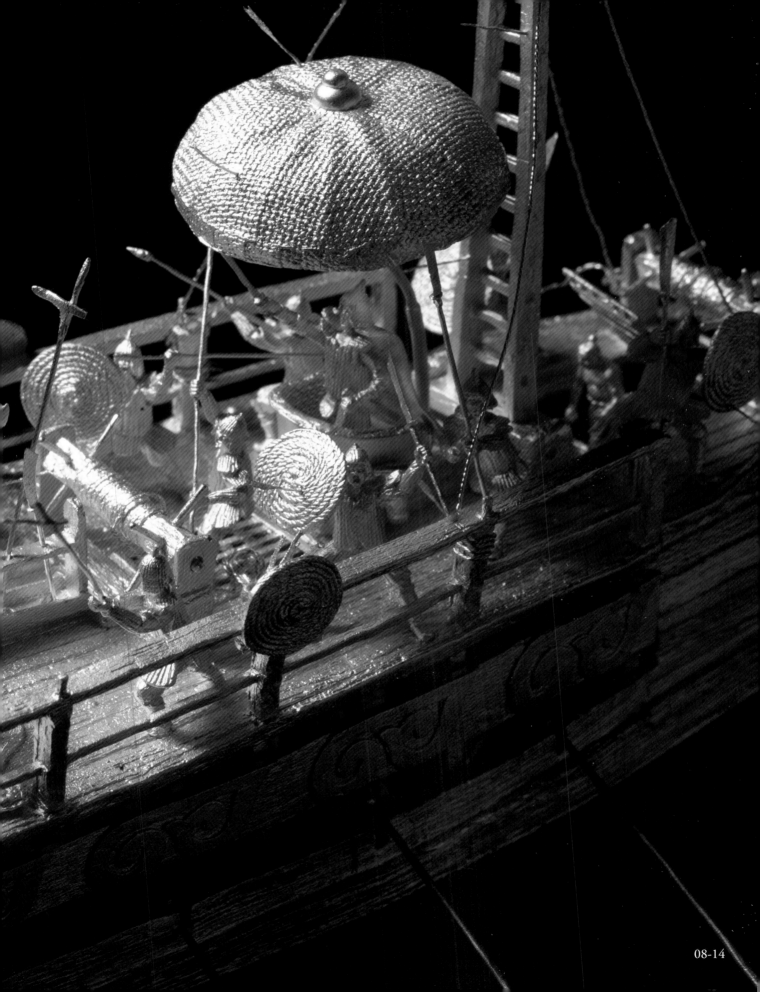

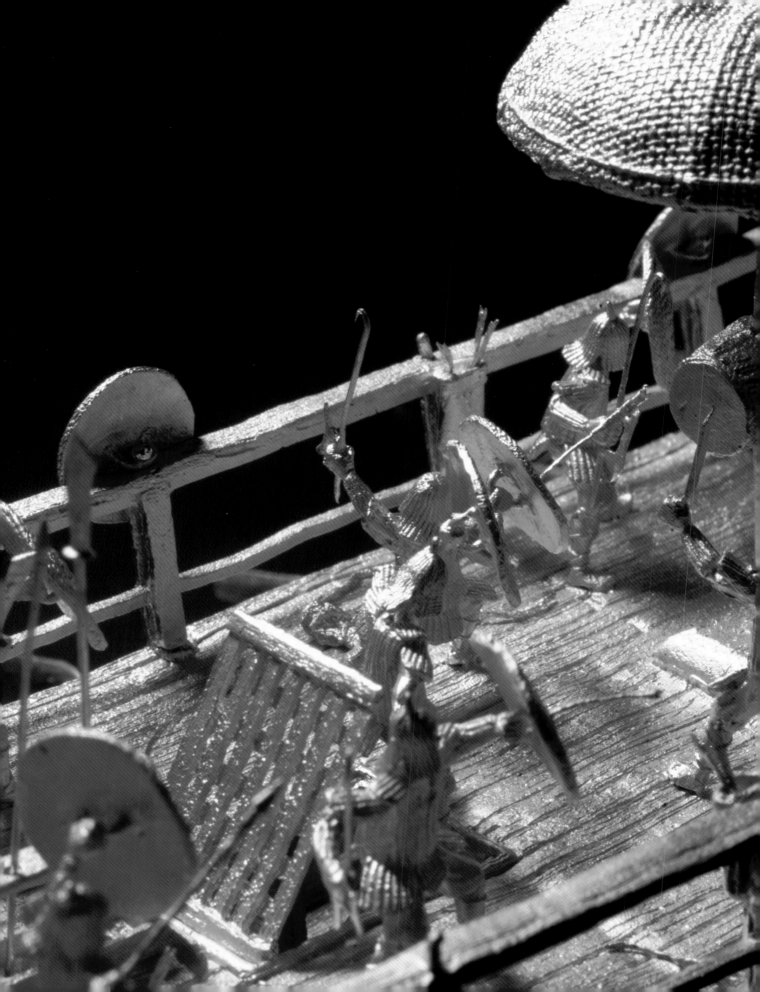

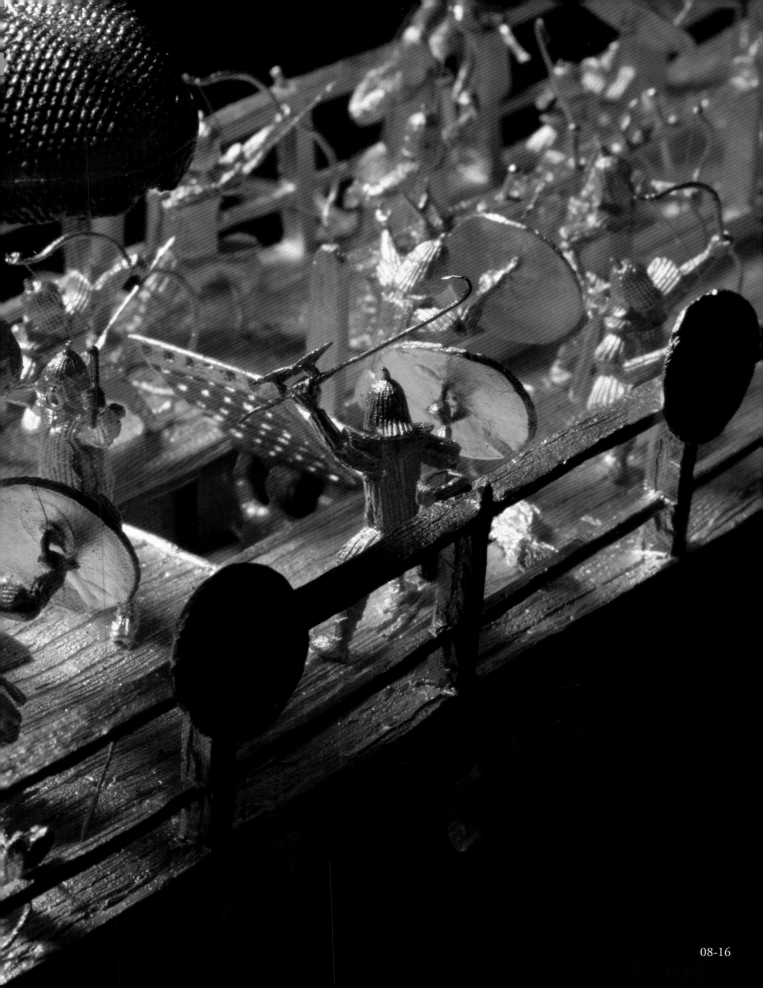

08-16

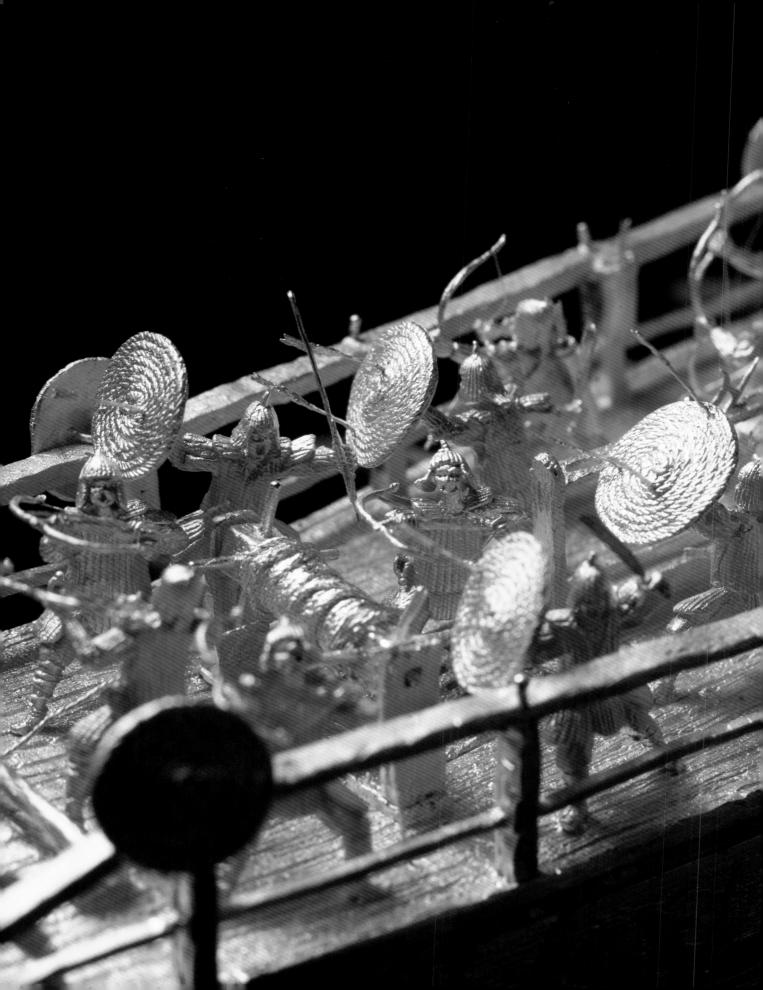

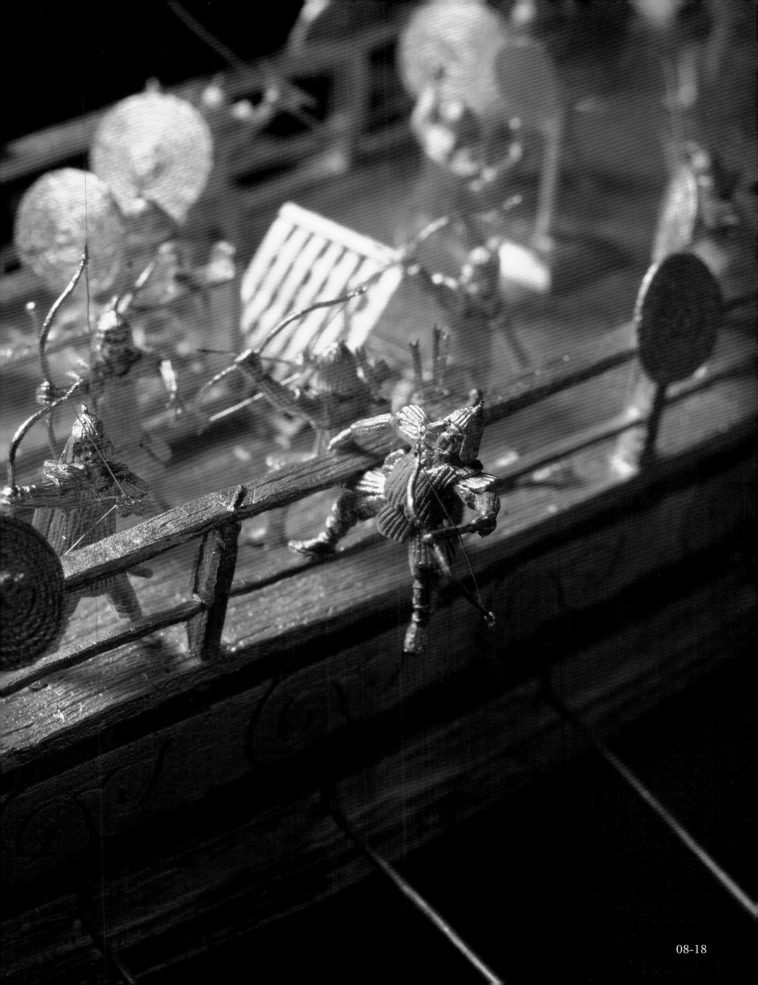

大翼戰船 （春秋時期東吳戰船） Da Yi Fighting boat The spring & Autumn period

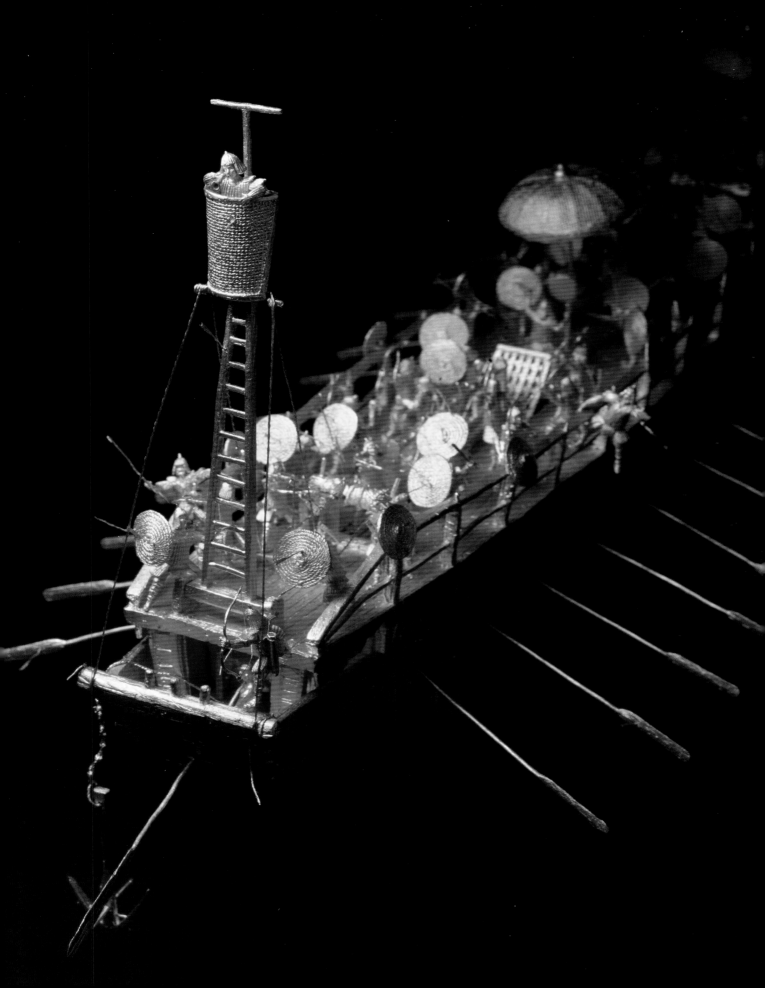

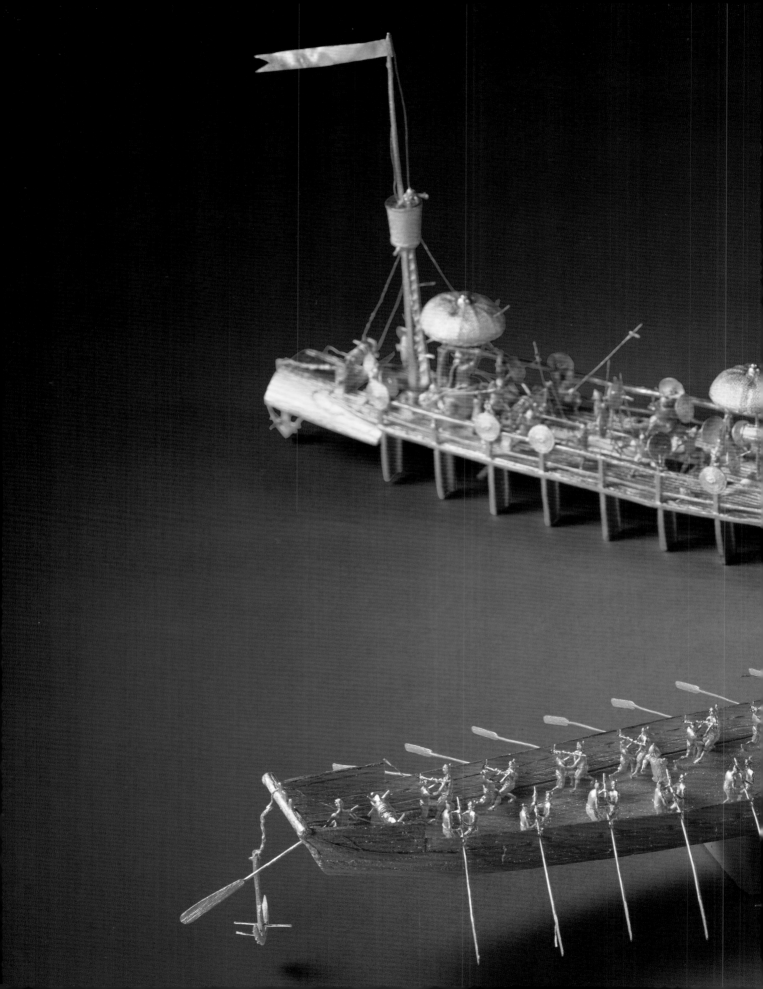

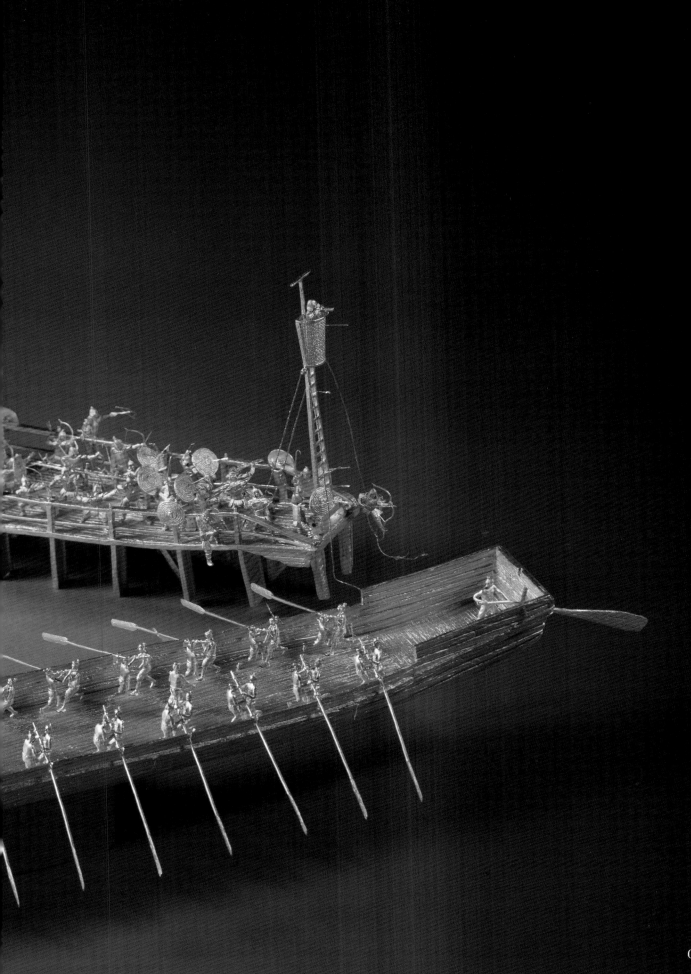

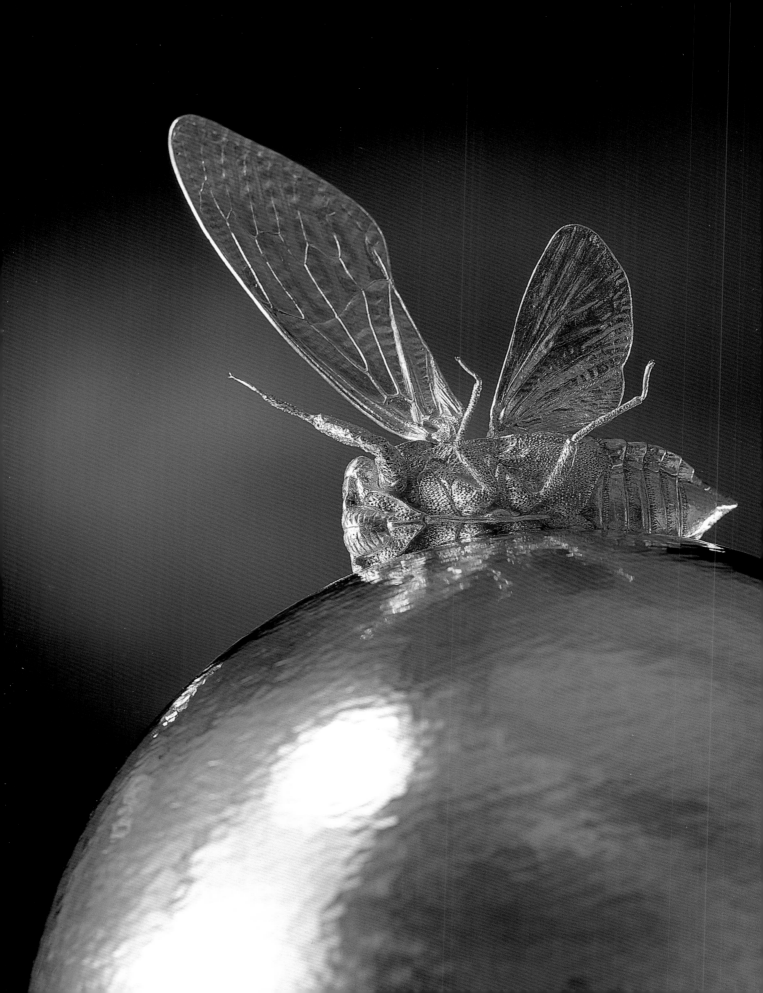

G02　護幼　Protecting the Young　純金60公克、瑪瑙　Pure gold 60g, agate　1990　13×9×23cm

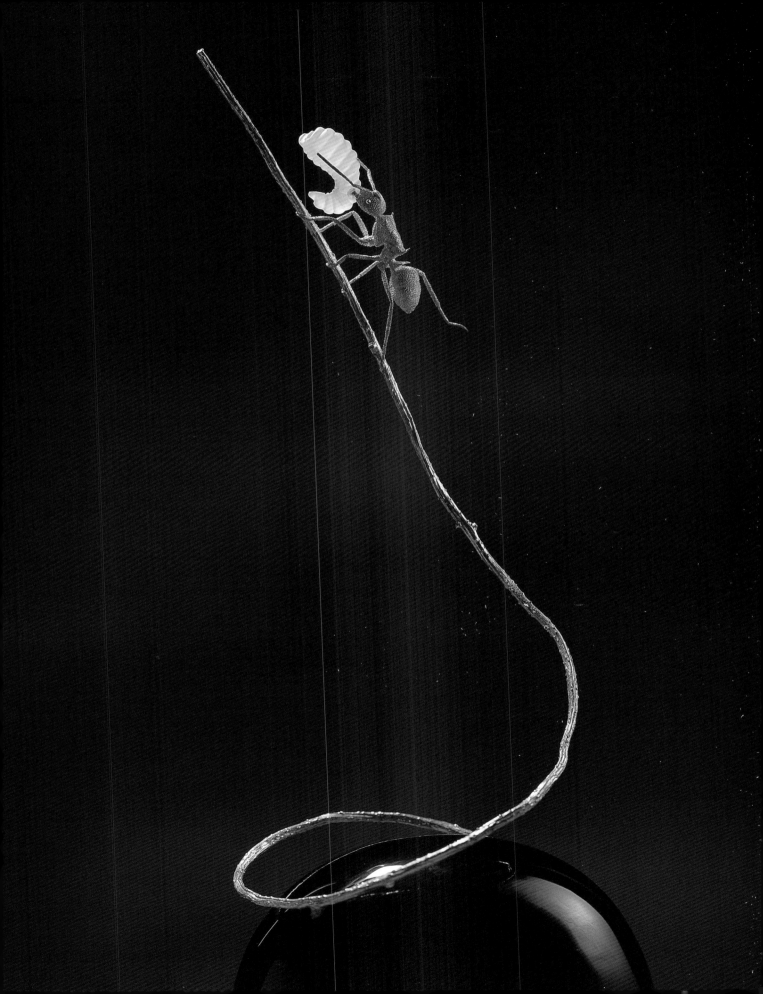

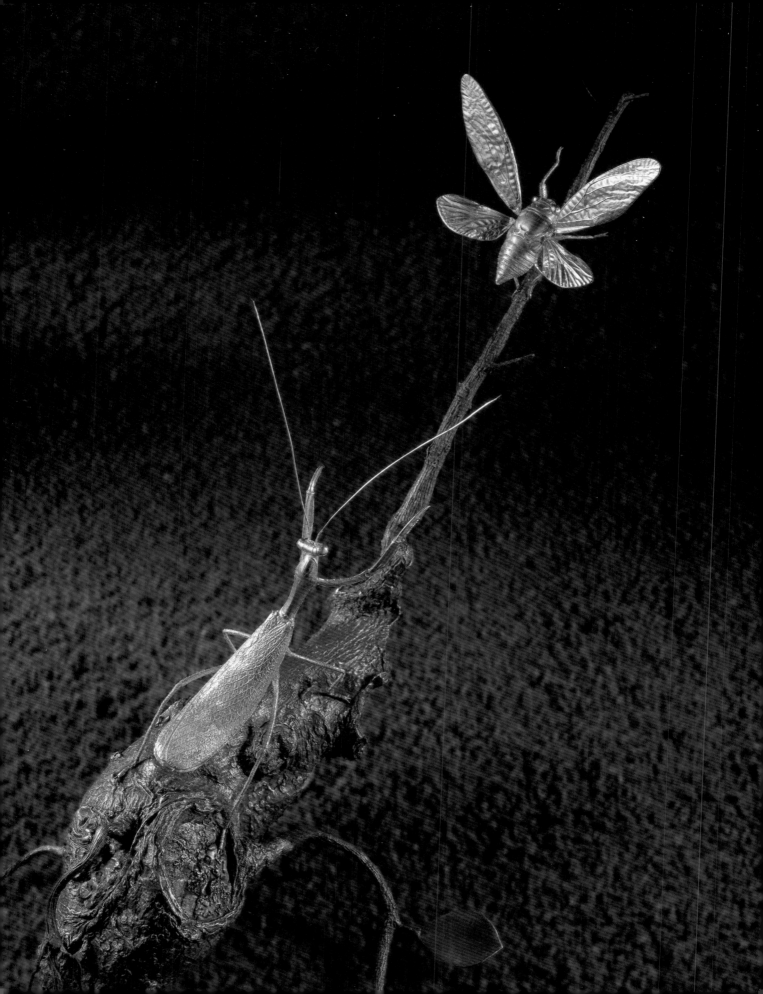

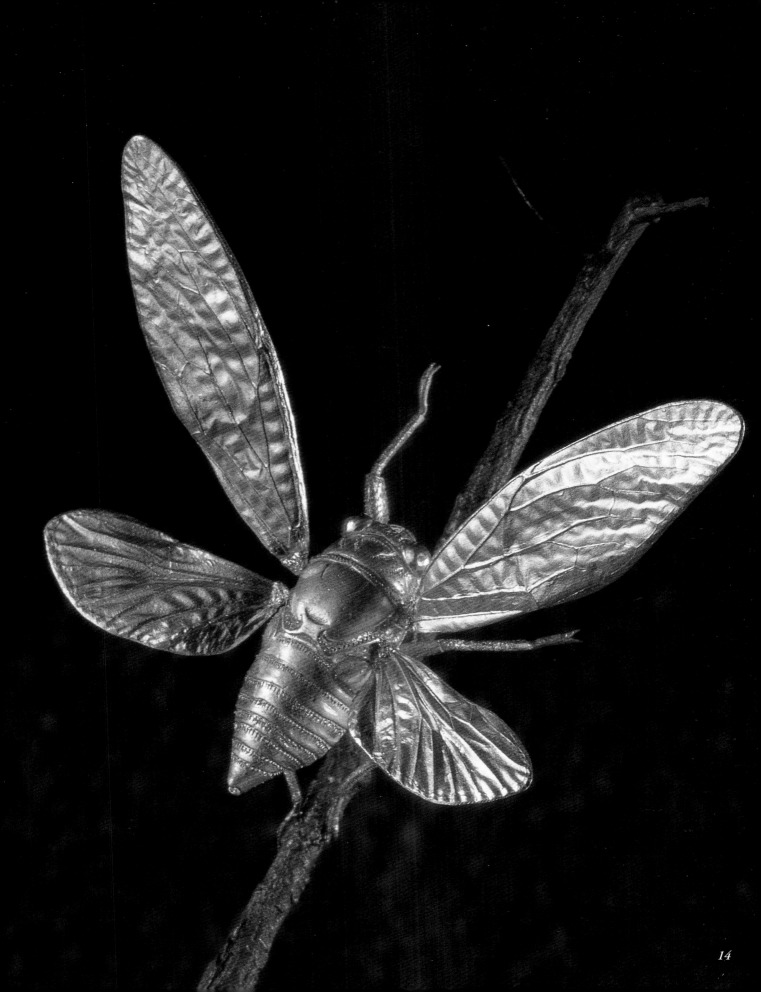

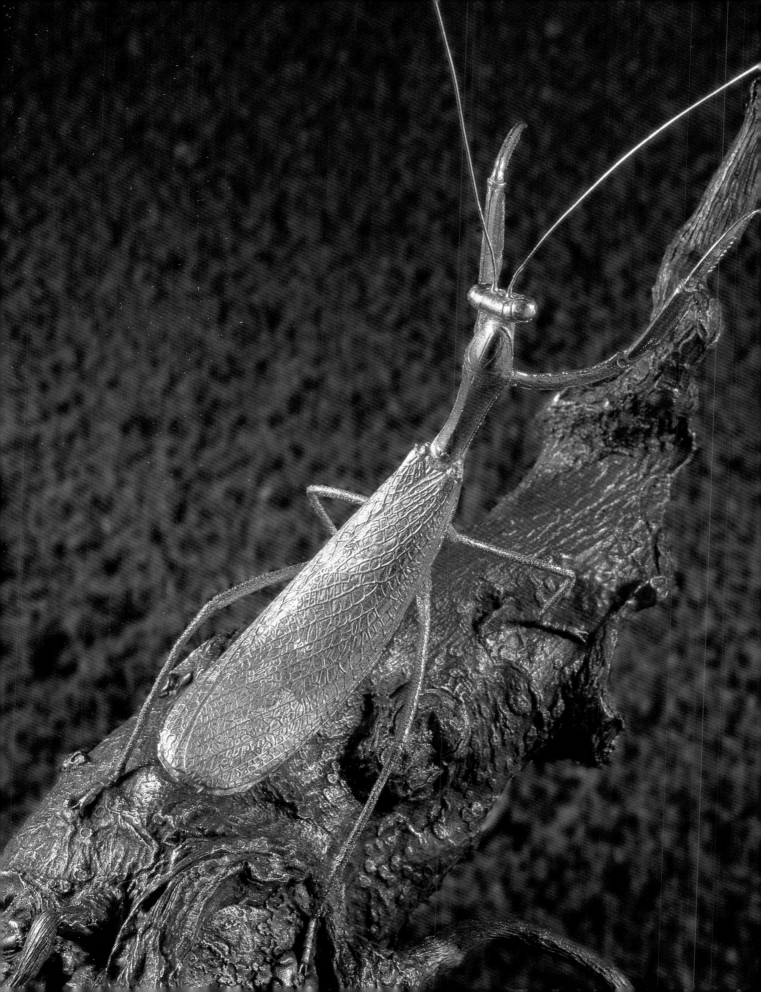

G04　蝴蝶蘭　　Moth Orchid　　純金5600公克　　Pure gold 5600g　　1990　　40×36×102cm

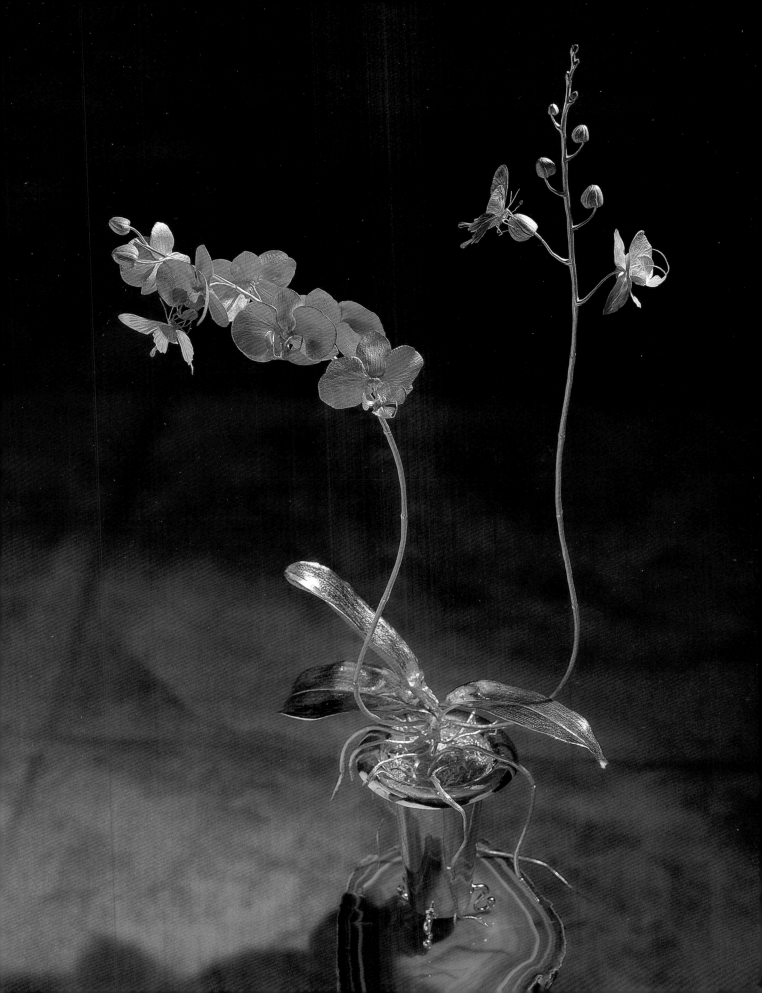

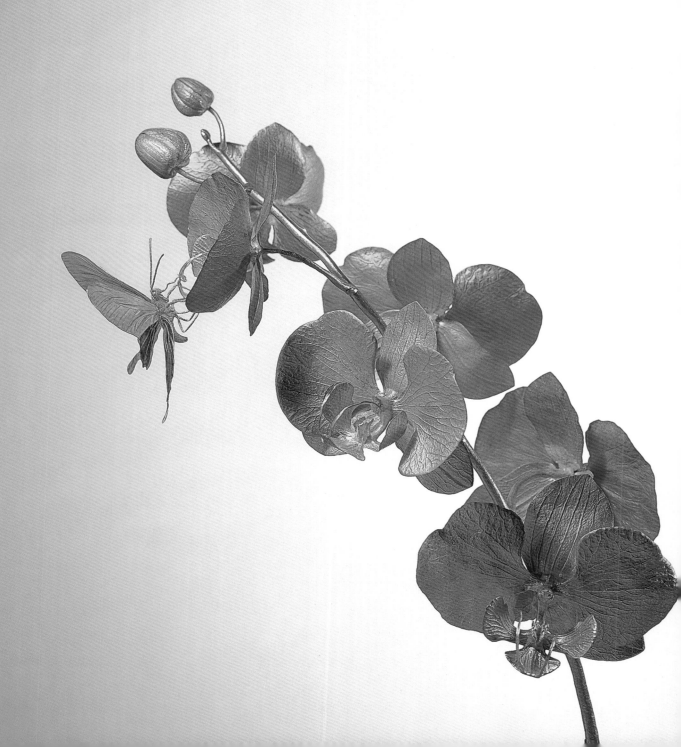

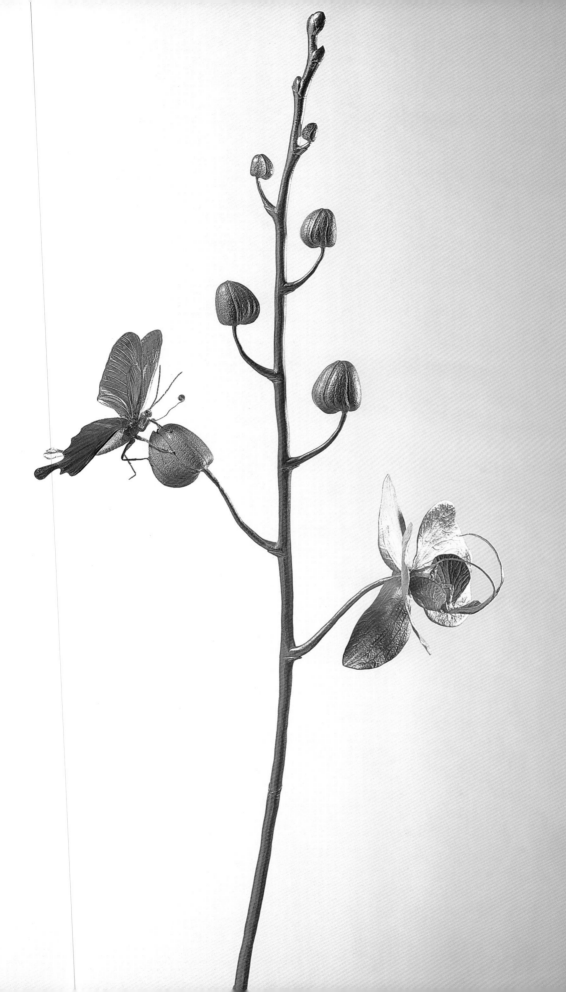

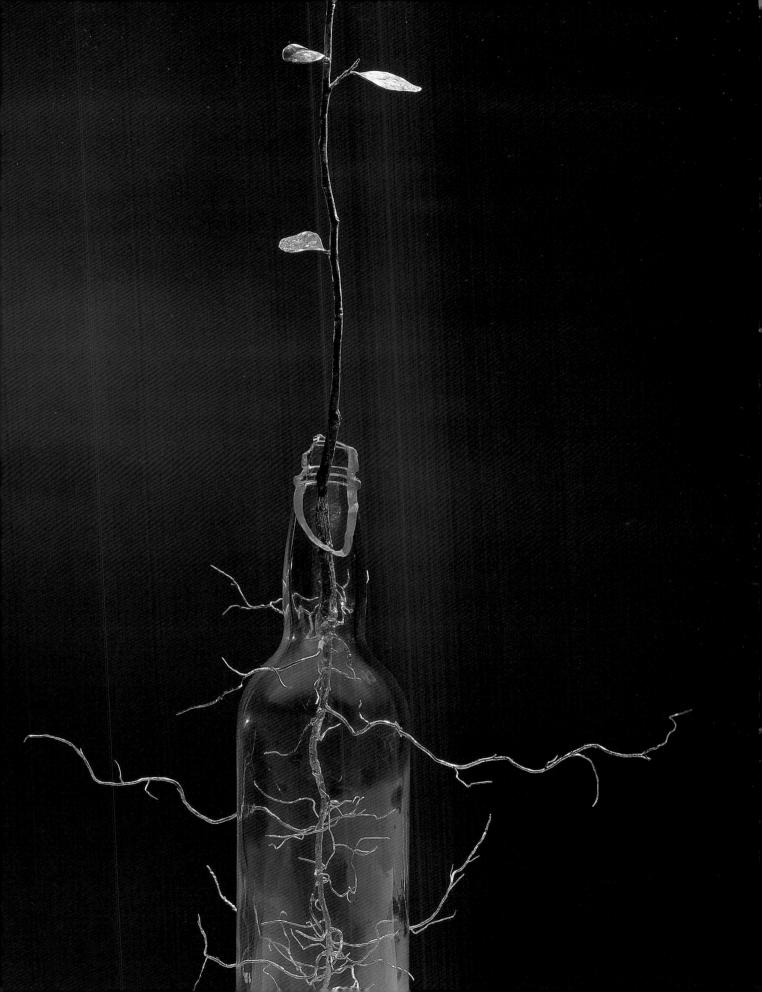

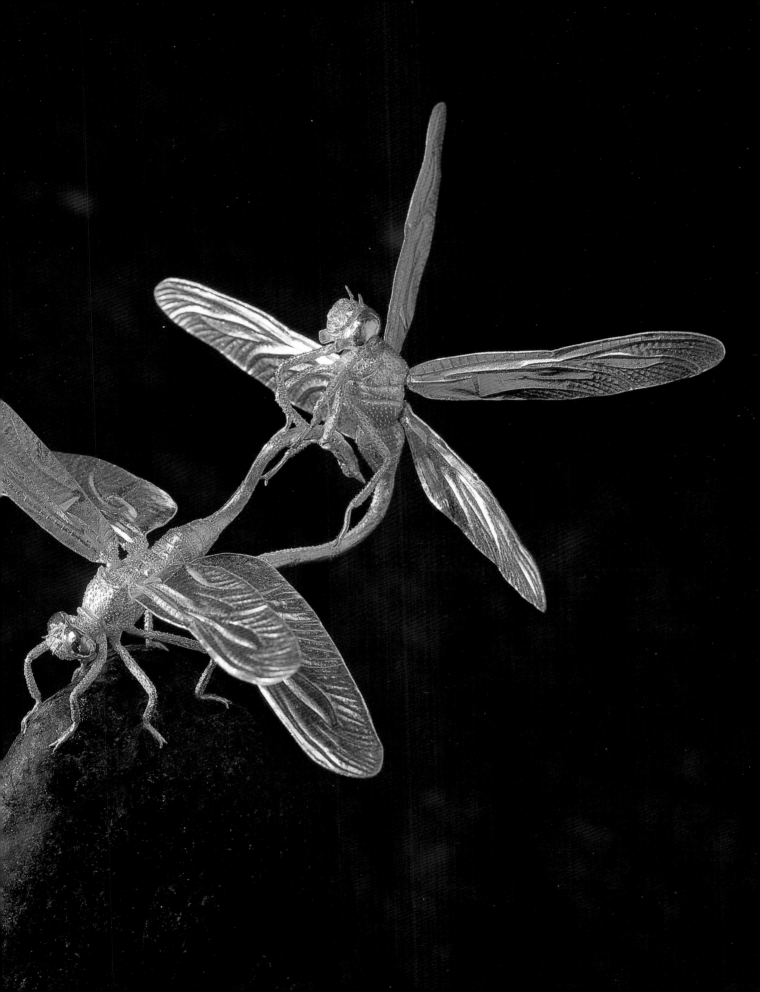

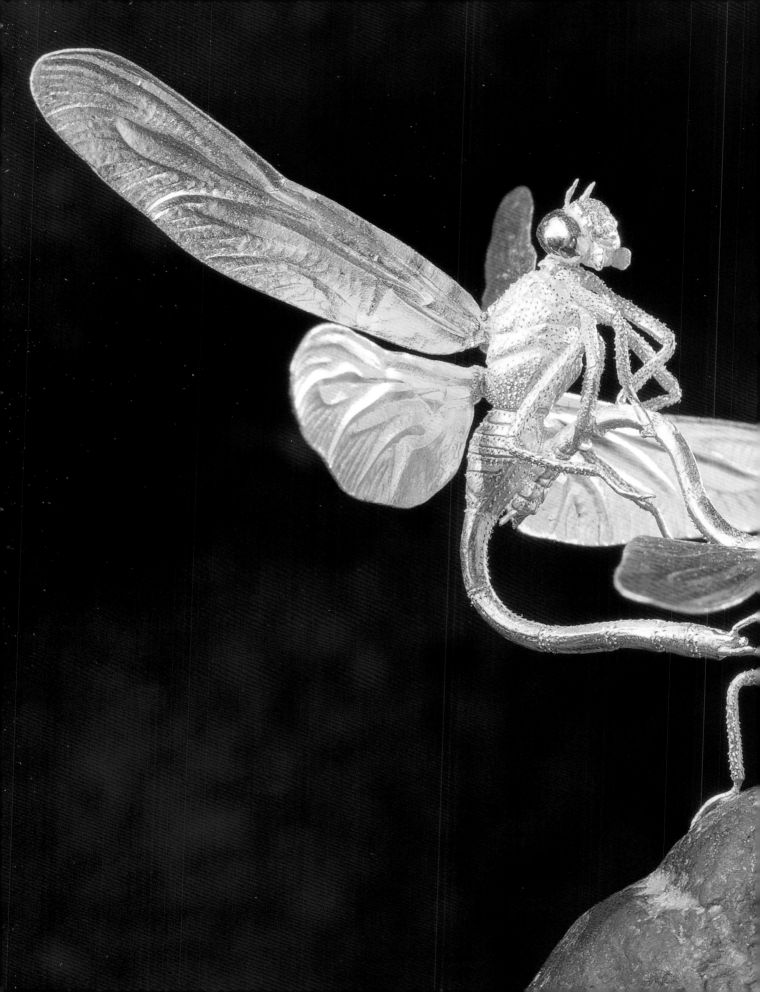

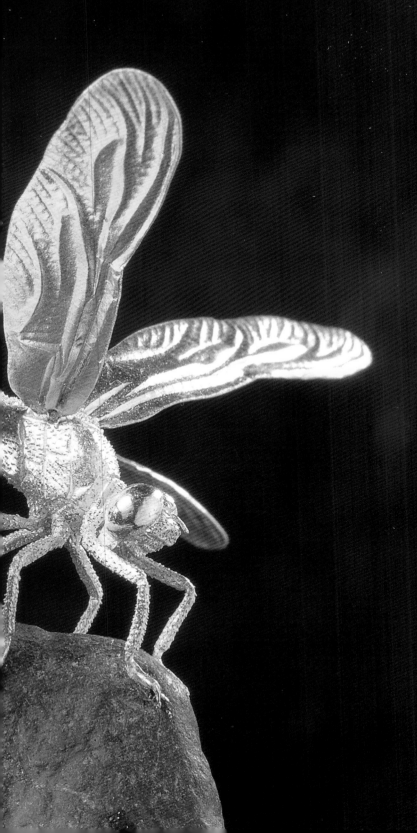

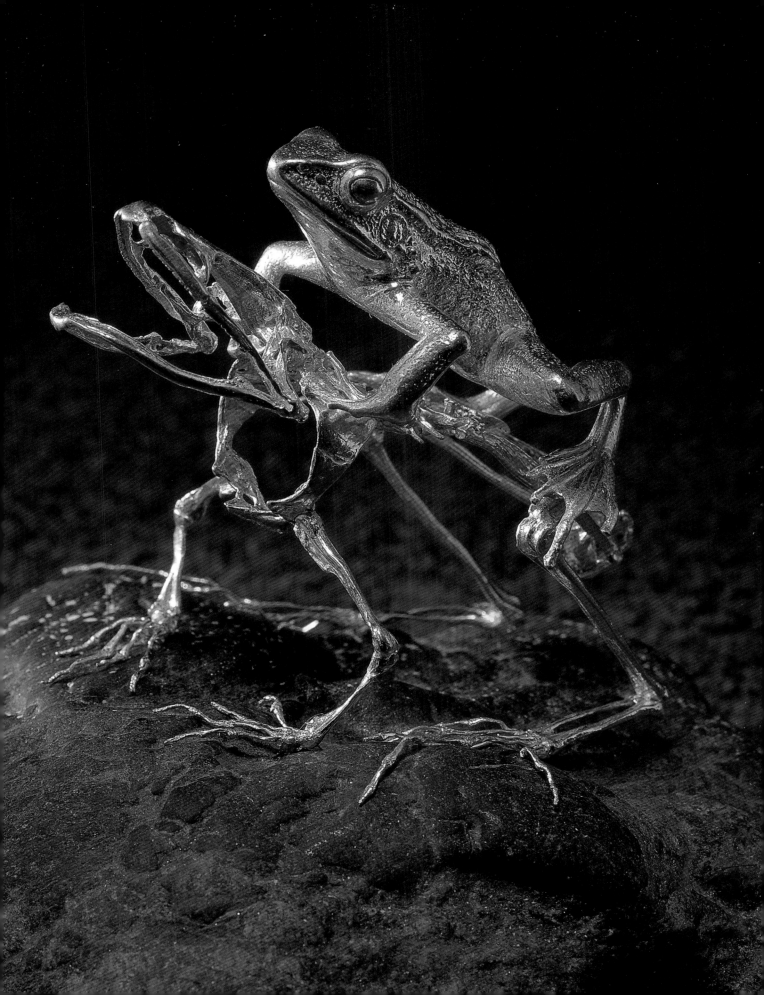

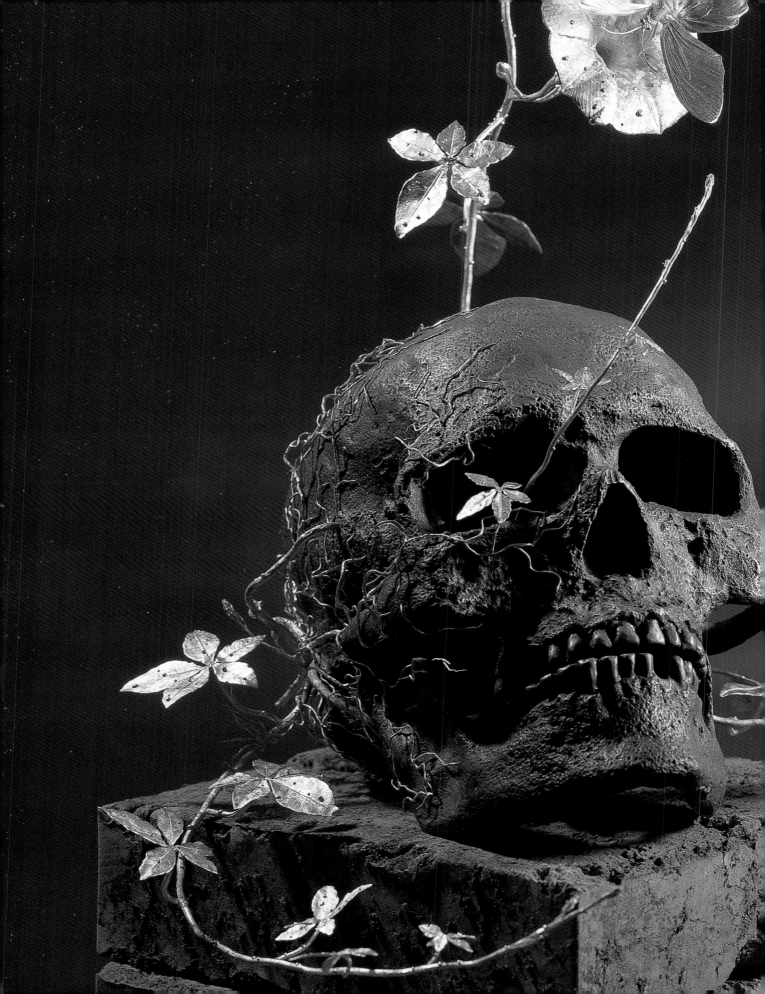

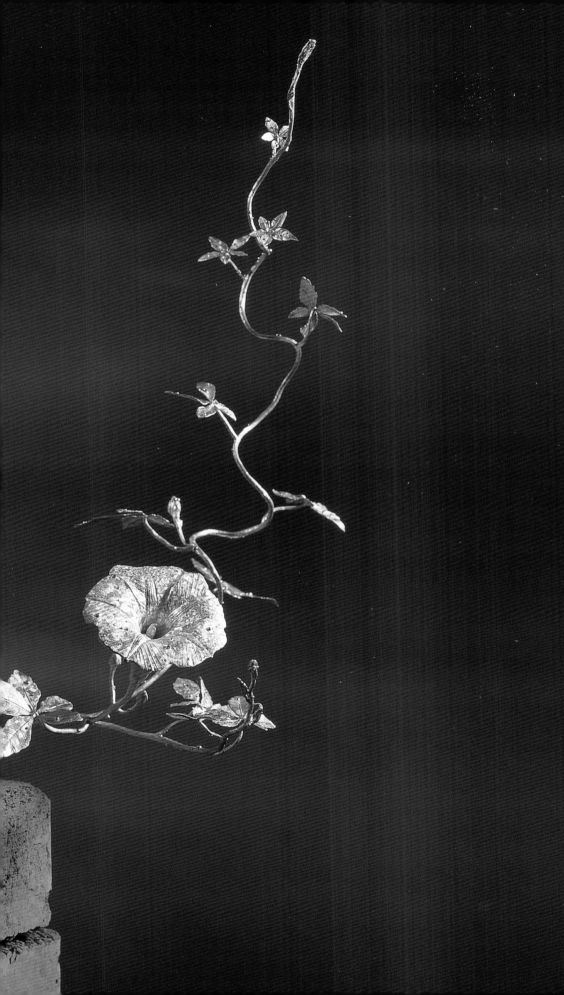

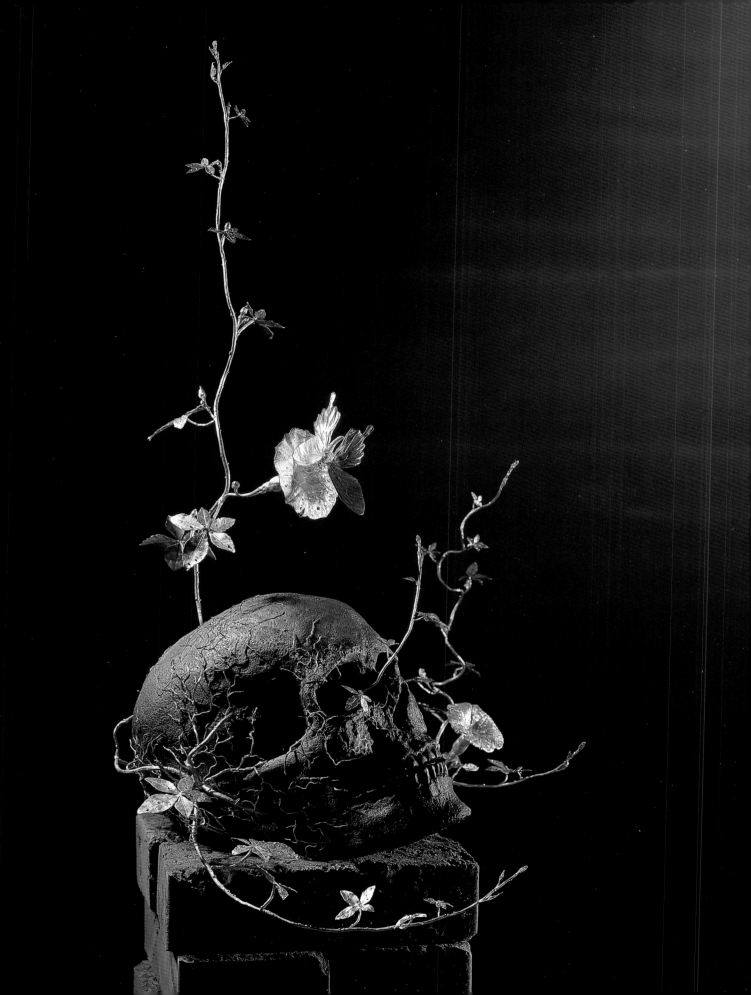

G23　　塵緣　　Mundane Affinity　　純金510公克、銀　　Pure gold 510g, silver　　1995　　40×32×57cm

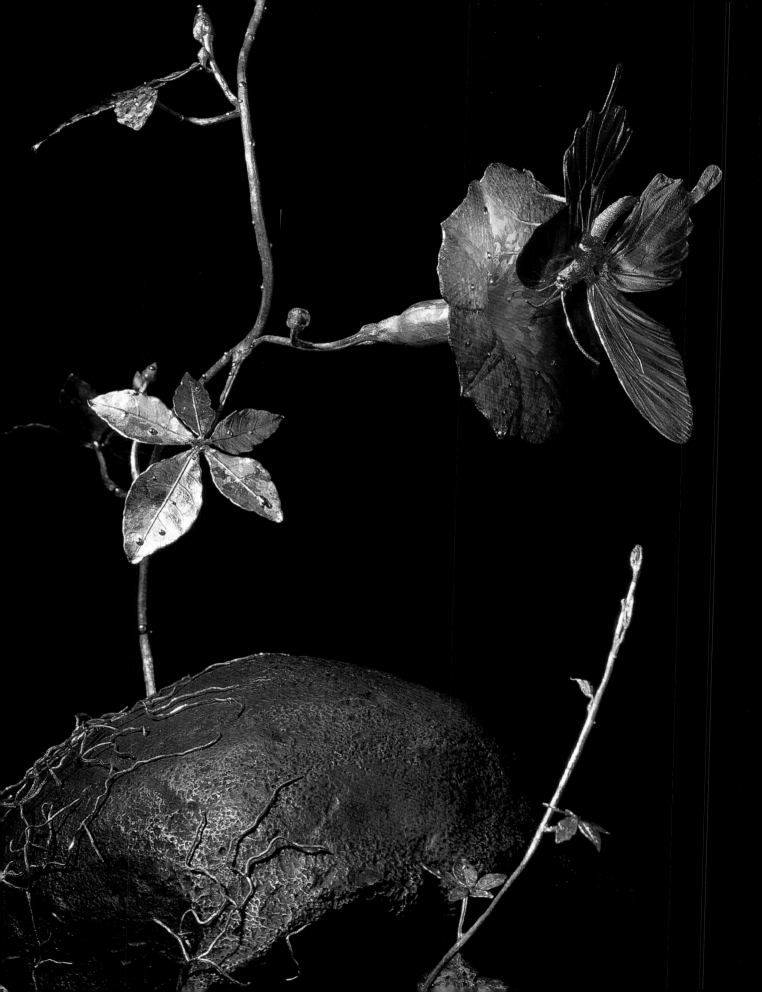

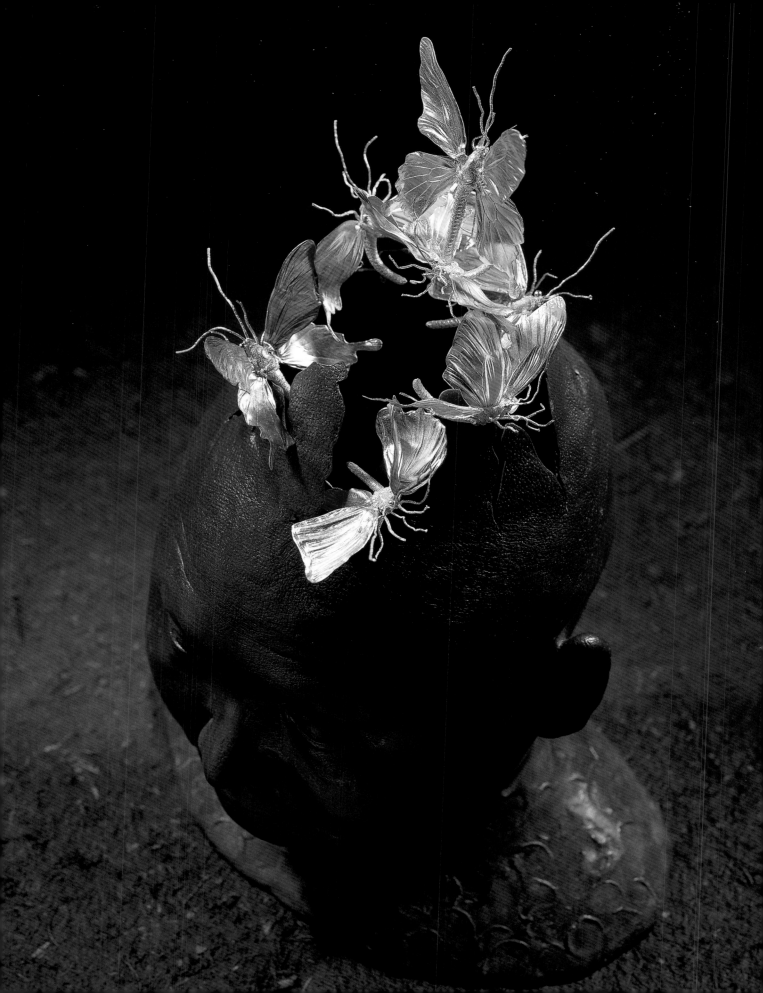

G31 　法喜　The Bliss of the Dharma 　　純金196公克、銅　　Pure gold 196g, bronze　　1996　　26×22×48cm

顯微宇宙中的宏觀

吳卿的雕刻世界和生命歷練

The Macroscopic View in Microcosm

The Life and Art of Wu Ching

　　一個在台灣南部嘉義縣鄉下小村落，一戶務農大家族出生長大的孩子，在入小學時只到過月眉、新港等鄰近地方，因此心想：「老家的住址為100號，總統府大概是1號，感覺世界實在很小，很沒有意思，有著一股落寞感，希望追求寬廣的空間。」（註1）這個經常逃學打架的頑皮孩子，在小學還沒畢業前就曾和同伴相約，拿著包袱準備逃家到台南打天下，但計劃未得逞，被抓回家遭父親痛打。進入國中仍經常蹺課，不學無術。畢業後四哥要他繼續升學，他卻已打定主意，先出外了解外面的世界，一年後再回來考藝專。渡過一年在外到處打工的流浪生活後，回到家鄉新港，原想履行的升學計劃，又因一次衝動的毆打事件而中斷。這個當年很有自己主張，不甘生活空間視野的侷限，又有勇氣反抗現有體制的不安靜少年，就是今天以禪定般的專注工夫和無邊的耐心，做出精微細緻雕刻藝術作品的吳卿。

　　吳卿十七歲開始拿雕刻刀，時值台灣做紅木、黑檀等高級木雕傢具外銷的全盛時期，於是從這項民藝入手，由新竹廠的八美圖「開臉」做起，又到台中、屏東、台南、台北等地嘗試平板紋飾雕刻，同時展開三年坐遊覽車四處遊歷觀摩雕刻技巧的流浪手藝人生涯。他看遍全省的廟宇和各地好的雕刻品；也曾兩次造訪當時被公認為木雕第一高手的朱銘工作室。在這段時間，他嘗試過的立體造型有孔子紀念像、觀音菩薩及媽祖等神像還有佛像雕刻。透過同學及其他同行朋友，他也開始去暸解不同工具的使用方法，和不同雕刻材質的特性。

大決心・傻氣・理想

　　以螞蟻生態為創作題材，和吳卿在第一次參觀台北故宮博物院的翠玉白菜、象牙球、河舟記等傳統精工細雕時，內心在驚嘆之餘所許下的心願有關：決心找一個最細的東西來研究，作出可以進入故宮的藝術品。（註2）一次偶然的機會，他坐在河堤上無意中發現螞蟻群合力搬運壁虎蛋的情景，一方面驚訝其團結力量的偉大，一方面也受大自然中造型的優美所感動，便決定以螞蟻的細密造型磨練自己的雕刻寫實技巧。

W03 掙脫 Struggling for Release 檜木 Juniper 1984 31×31×380cm

攝影／黃送昌 Photograph by Huang Sung-Chan

Born to a suburban country home in Chiayi, a southern county in Taiwan, Wu Ching is a country boy who never traveled further than the neighboring villages such as Yuemai or Shingang before he entered elementary school. In his young mind, he would ponder "if the address of my home is number 100, then the Presidential Hall would perhaps be number one. The world feels small and thus not particularly exciting. A sense of loss emerges, and a desire for exploring the world takes shape." ❶ This naughty boy played truant and caused troubles. Before graduating from elementary school, he contrived a plan with his friends to escape to Tainan for leading a new life. Yet, to his disappointment, not only was the plan stopped short, he was caught by his father and was severely punished. Continuing his education in a junior high school, he was still that mindless student. His forth-elder brother intended that he should pursue a degree with senior high school education; however, the young Wu Ching drafted a short-term plan for himself to explore the outside world, then continue his education in the Academy of Art. After one-year fooling around as a part-timer, he returned home to fulfill his promise for further education; unfortunately it was again interrupted by a vicious fight. The then self-opinionated youngster, who rebelled against the institutional regulations and challenged the rules of a limited world view, has now matured into an artist with Zen concentration and immense patience, who creates a new canon of the most refine carvings.

By the age of seventeen, Wu Ching started to learn carving. It corresponded to the high time of the fine carving wood furniture in Taiwan's export business. Being an amateur folk artist, Wu Ching began his career by engraving the face of "The Eight Beauties" at a factory in Hsinchu, while also tried his luck in different places such as Taichung, Pintung, Tainan and Taipei. During this period, he traveled all over the island to observe the craftsmanship of carving. His destinations included temples, exquisite sculptures and carvings done by renowned artists. He twice visited the Studio of Ju Ming, which enjoyed the reputation of being the best in Taiwan. Also around this time he sculptured statues of Confucius, Guanyin, Matsu, and other Buddhist idols. Through classmates and peers, he acquired knowledge on the different applications and

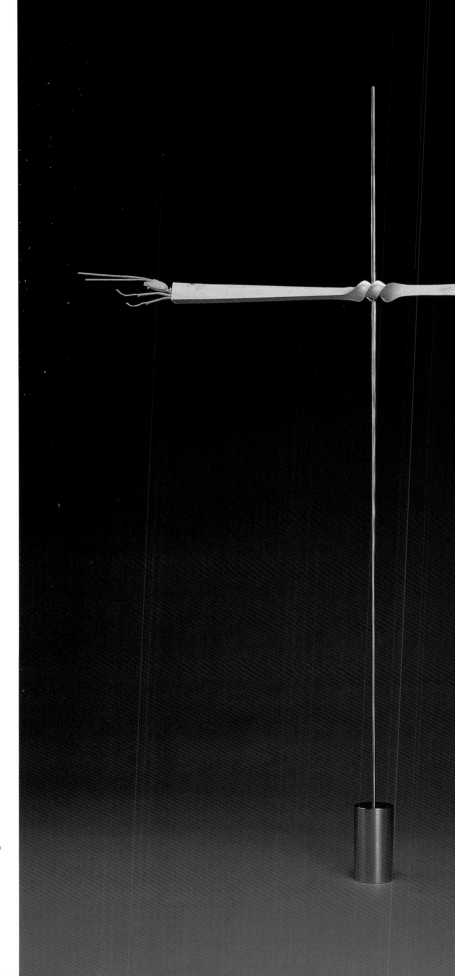

從拿著放大鏡到處找螞蟻觀察，
到自己飼養螞蟻，吳卿發現台灣北
部和南部不同蟻類具有不同的習
性，更發現到螞蟻之間也有情感和
慾念；在螞蟻的世界中牠們能組
成一個公平、合理的社會。將螞蟻
以不同倍數比例放大所作的木雕系
列，除了令人歎為觀止的寫實功力
外，吳卿也企圖在作品中傳達自身
情感的抽象意念。如〈掙脫〉和〈穿
梭〉，表現他心中想要擺脫自我束
縛，超越時空的慾望。1982年的第
一件大型作品，長達10呎的〈搬運飯
粒的一群螞蟻〉，是他用生命中最
年輕的4015個小時雕刻完成的。這
件作品在隔年台北市立美術館開幕
展中大放光芒，「螞蟻」成為吳卿的
專業題材，並且在往後的金雕開拓
過程中，成為另一次技術性克服的
大挑戰。

1993年台北故宮博物院破例要購
藏吳卿的金雕作品，當時的秦孝儀
院長，請他製作尺寸更小的螞蟻，
「瓜瓞綿綿」系列作品於是產生，
其中螞蟻以外尚有七種昆蟲與苦
瓜藤，組合的複雜度和製作難度，
令觀者無法想像。吳卿在十九歲
時許的願（1975），於十八年後實
現了，他的作品被典藏在故宮博物

穿梭　Shuttle　黃楊木　Boxwood　1986　66×5×77cm
攝影／黃送昌　Photograph by Huang Sung-Chan

characteristics of tools and materials for woodcarving.

Determination, Persistence, and Ideal

The first visit at National Palace Museum confirmed his determination to become a professional sculpturer; more than that it inspired him to create a series based upon the ecology of ants. Masterpieces such as Bok-choy Cabbage and Katydids and the Ivory Ball fascinated him with exquisite traditional craftsmanship. He decided that he should work on the tiniest object, so that his works could make it into the National Palace Museum. ❷ It all started by chance that he became enchanted by ants. One day, he spied a number of ants carrying a gecko egg, and he was completely amazed by the great strength that came as a result of cooperation. Deeply moved by the dynamics of nature, he determined to carve ants as his first training course in carving.

To achieve virtuosity in ant carving, Wu Ching never lost any opportunity to observe ants with a magnifier; and to learn the ecology of ants, he started to keep a colony of ants. By this unique experience, he was able to appreciate the minute differences between the ants of the northern and southern parts of Taiwan, to observe the hierarchy of this social insect, and to interpret the love and desire of ants. By carving ants of various sizes in perfect proportion, Wu Ching impressed his spectators with an unsurpassed verisimilitude. Aside from the similitude in shape, he also tried to convey abstract ideas such as his emotions through his works. Works such as "Struggle for Release" and "Shuttle" express his desire to liberate himself and to transcend the limitations of time and space. In 1982, the first large-scale work, "Ants Carrying Rice" was completed, using 4015 hours in the

院。另一件以螞蟻為主體的生態作品「鄉野情懷」，也是他到目前為止最大的一件金雕作品，上面有806隻大大小小的螞蟻；做一隻金螞蟻需要一個工作天，三個螞蟻巢以銀片手工鍛打，費了三個多月，加其他植物、昆蟲與泥土狀底座，整件作品共耗時一千兩百天才完成。誠如吳卿自己所述，做這件作品的動力是下大決心、傻氣和理想，也算是對自我的一個交代。他當時剛好四十歲。

木雕‧金雕‧共生同體

　　「木頭是有機的，和生命較契合。雕刻木材是一種〝減法〞，一刀刀剔除、鑿空不要的部份，所要的型體就逐漸呈現；木料變得越少越輕，歡喜就越多。金雕則完全不同，製作過程是一種〝加法〞，將所要的形體分解，以鑄模塑造和平模壓製方式完成各部位再走水組合，是一種增添的樂趣。我個人喜歡木質的雅、溫潤；木雕較具挑戰性，作品也較具有親和力，更何況我和木頭有二十多年的特殊感情。」
吳卿在工作室徐徐闡述他對兩種不同材質特的創作經驗。

　　過去十多年吳卿的金雕作品所受到的矚目，遠超過他的木雕，很多人恐怕不知道，每一件金雕的胎體原型其實是木雕，除了少數植物枝葉以原物翻製外，吳卿都是先雕做完整的木刻作品，再以之翻模鑄造金雕，所以他的木雕是金雕之母，兩者有一種共生同體的關係。使用的木料他多選黃楊木，那是一種紋理最細密，質地最堅韌，色澤光潤如象牙的上等精雕木材，但生長速度極緩慢，一塊直徑寬度足以雕作頭像的黃楊木通常樹齡已達上千年。這也就是為什麼以一般蠟模無法翻出的細度和質感，吳卿做到連義大利的金藝師傅都辦不到的成果，細緻堅韌的木雕模是關鍵。至於配合創作的工具，吳卿也有一套獨家的雕刻利器，他改造德國和瑞典的車床鋼刀、日本的木雕刀，將刀鋒的斜度和刃長鍛磨成符合自己的需要。牙醫的全套整修工具他都有，外科醫生用的手術刀，他也試過。

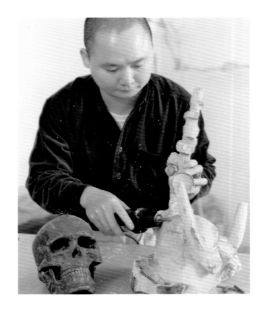

吳卿創作木雕〈塵緣〉的
階段過程　1989—1991
Wu Ching was working
with "Mundane Affinity" in
different process, 1991-1992

youngest part of his life. The next year, it was exhibited at Taipei Fine Art Museum, and was highly praised. Ants become the trademark of Wu Ching, and will continue to challenge his artistic career as he explores the art of gold sculpting.

In 1993, when the National Palace Museum made the exceptional decision to collect Wu Ching's work, the then Director Dr. Chin Hsioa-yi commissioned him to compose even smaller ants. "Prosperous Descendents" is the work created for this specific purpose. Aside from ants, Wu Ching accommodated in this work seven other insects and intricate vines of melon, which rendered a complexity and difficulty way beyond imagination. The wish that Wu Ching made as a nineteen-year old youngster was materialized after eighteen long years. His work is now treasured in National Palace Museum. "Reminiscence of Rustic Pleasures," the largest gold work up to now, is another important work in the Ant Series. There are about 806 ants of different sizes with three nests, the former carved from gold while the latter fabricated by silver plates. One single ant would take a whole working day, the three nests three whole months, plus other insects, plants and the soil base, the work as a whole took the artist more than 1200 days to accomplish. As the artist himself said, without strong motivation supported by determination, persistence, and ideal, it is impossible to work on a work of such scale. "Reminiscence of Rustic Pleasures" is a milestone for the then forty-year-old artist.

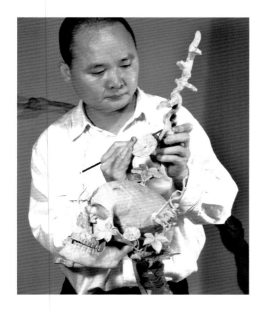 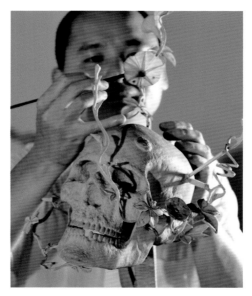

寫「真」之外 · 技巧之上

　　過去媒體褒揚吳卿作品的焦點落在他的寫實技巧上，一種重現故宮國寶級傳統光輝的所謂「鬼斧神功」；一種讓我們重拾某一部份民族自信心的歡慰。但這也恰是藝術界貶抑他的要點，更是他個人奮力往獨立藝術創作路途上的大礙。若能跳開對吳卿作品那神乎其技的視覺寫實表象的專注，也不再執迷於貴重金屬的「金」光絢爛，而以平常心，直接和吳卿的作品相遇，作心靈對話，他那寫「真」之外，技巧之上整體散發的創作熱能是不需語言和文字傳達的，而當觀者不再聯想「黃金」的通俗意義；不再去辨識作品的題材有「多像」時，就可以和吳卿的心念作最深切的的溝通，可以領受最多的喜樂。筆者從西方異域歸來，腦中只有二十年前北美館的螞蟻實物印象和台北傳給我的一堆密密麻麻的圖文資料。在吳卿的工作室，是他的作品，尤其是幾件未曝光的木雕，很直接地說服我想要好好認識這位在台灣受到不同爭議的創作者。

吳卿與作品〈禪〉木雕原型攝於工作室　2003
Wu Ching and his woodcarving "Zen" prototype, 2003 in studio
攝影／林日山　Photograph by Lin Ryh-Shen

攝影／黃涓　Photograph by Huang Chuan
2003

Wood Carving, Gold Sculpting a Symbiosis

"Wood is organic and has a life of its own. Wood carving is a process of reduction, in which you cut off whatever you don't want as your object takes its shape. Gold sculpting is completely opposite in that it is rather a process of addition. First, you need to anatomize the parts and pieces, and then with different molds, you shape each part, and finally fuse the parts to formulate the complete work. Personally I prefer wood carving because the elegance and placidity of wood make it more challenging. Moreover the more than twenty years immersion in wood sculpting also makes it feel intimate." Wu Ching thus said about the different natures of wood and gold carvings when he analyzed his experiences in his creative career.

In the past ten years, Wu Ching's gold works claim far more attention than his wood carvings. Yet most people perhaps did not know that the all his gold sculptings take shape from a wood mold. Aside from the few exceptions such as the leaves and branches of plants, Wu Ching almost always completed the wood mold first, then transplanted the model to gold. By doing so, wood and gold formulate a symbiosis. Amongst different wood materials, boxwood, featuring a close-grained, and hard texture with a beautiful ivory hue, has been the wood that is especially favored by Wu Ching. It is a slow-growing shrub and a block large enough for sculpturing a bust would require a boxwood of at least over a thousand years. The refine wood mold could imbue a subtlety that is not possible with a wax mold. That is the secret for Wu Ching to produce the most refine gold works, which even the Italian goldsmiths cannot compete with.

Wu Ching attentiveness can also be observed from the tools he chooses for creation. He improves different types of carving knives and readjusts them for his specific purposes. His equipment ranges from the tools he mends for himself to a complete set of apparatus used by dentists as well as the scalpel.

在訪談過程中，發現他對各種雕塑材質的認知和工具技法的開發，不遜於歷史上的專業名家，也像歐洲著名的鑄造師一樣，保有走水銲藥和脫模王水的獨家配方。以一個只有國中畢業，自習自學，沒有受過學院藝術和邏輯訓練的人，卻能將木雕和金雕的方法論歸為「加減法」；而他的雕刻物體草圖，並非只是單純的素描，例如吳卿將昆蟲或動物的肢體分解，各部位再按比例放大，精確的運算出所要刻的實際大小至釐米零點數，在實務操作過程中，若有美學上的缺失或不和諧，再調整伸縮比例，以臻視覺上的完美要求。他是從實際經驗中領略美學理論中的「比例奧祕」。吳卿的腦力加眼力有如電腦中的3D高解析顯像器；手和刀的運轉又勝過機械性車床，但他說這是他多年參禪修來的定靜力和專注工夫。

蜻蜓分解比例運算圖（吳卿提供）
Anatomic proprotion notes of a dragonfly　© Wu Ching

Beyond Verisimilitude and Techniques

In the past, Wu Ching is chiefly lauded for his virtuoso verisimilitude because he revives the kind of awe-inspiring craftsmanship glorified in Chinese artistic heritage. Unfortunately, this is a failure criticized by the art circle, and it also blunders the artist on his way of creativity. However, if spectators can avert their attentions on Wu Ching's realistic representation, and elude the splendor of gold, they should be able to re-appreciate his works by a spiritual communion and feel the momentum embedded in his works. When they can transcend the general meaning of gold and stop comparing how realistic Wu Ching's representations are, then they can communicate with the deepest soul of the artist, and move on to experience the ecstasy of his art. When I first returned to Taiwan, my impression about Wu Ching was very much based upon his ant exhibition at Taipei Fine Art Museum some twenty years ago. A visit to his studio convinces me that I

毛蟹分解比例運算圖（吳卿提供）
Anatomic proprotion notes of a crab © Wu Ching

非有非無・有無皆空・不真即空

　　吳卿在未滿二十歲時為「創意」所作的定義是「做別人從沒做過的，做別人想到而做不到的。」(註3)，但現在他發覺為藝術而創作之後；真理才是他要追求的更高境界。自1980年學禪讀佛經以來，他的作品：〈掙脫〉、〈禪〉、〈無礙〉、〈夢蝶〉等木雕，及金雕的〈是人？是蝶？〉、〈塵緣〉、〈緣生緣滅〉、〈悲喜交集〉、〈法喜〉。一路探討的是生命中的有無、因果、虛實、出世入世等相互存在的關係，也包括自然生態和人類的共生關係（symbiosis）彼此牽連互動。吳卿的作品看久了，會覺得那「超寫實」的「實相」，只是人世中的「借景」，是用來說明那「虛無」幻化的部份。這次展出是他創作生命的一個段落，他準備在近年內推出完整的木雕回顧展，呈現最貼近他生命本源的真誠記錄。吳卿還不到五十歲，生命中追求心靈故鄉的「奧迪賽」（Odyssey）之旅，才駛到中點，不是嗎？！

（黃涓 採訪撰文）

註1、2、3：取錄自台北藝術大學文化資源院院長林保堯教授與研究生多次和吳卿訪談所作的實錄「吳卿大事記」，2001年初稿

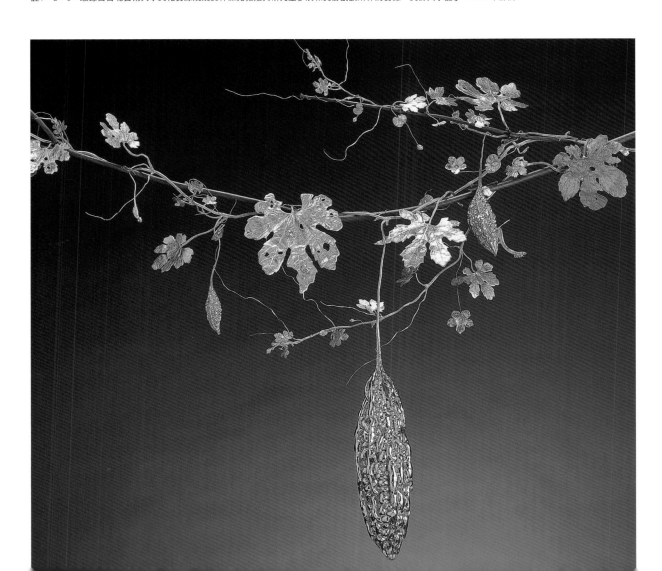

need to rediscover the craftsman who has already metamorphosized into an artist.

In the interview, I realized how his devotion spurs him to explore and develop materials and tools as a professional. Without formal academic training, he is schooled by incessant trials and errors. With indefatigable efforts, his knowledge can compete with renowned professional worldwide. The innovative theory about wood carving as deduction versus gold sculpting as addition also strikes with wonder, especially in one with only a junior high school degree. His drafts for carving are never simple sketches. He would anatomize the insects and animals in a scientific manner, then upsize the objects in proportion with stunning precision. All his works have to go through numerous revisions in order to achieve visual perfection. As a perfectionist, Wu Ching will not tolerate any aesthetic flaw or discord. His grasp over aesthetic theories comes from practices, which enable him to use eyes and brain with more accuracy than the three dimensional calculation of a computer, and hands with more exactitude than the mechanical lathe. He confessed that without Zen meditation, he could never achieve such concentration and attentiveness.

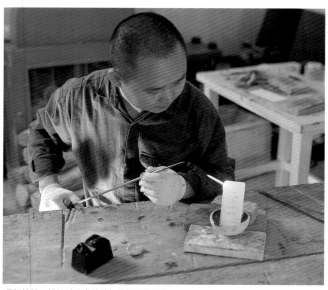 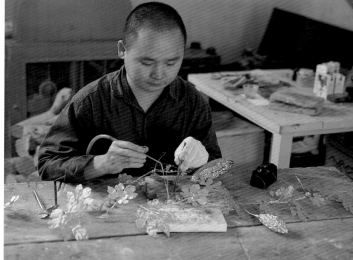

吳卿熔鑄、焊接〈瓜瓞綿綿〉作品純金部份　1991
Wu Ching casting and welding the pure gold parts of "Prosperous Descendents"　1991
攝影／黃送昌　photograph by Huang Sung-Chan

左頁：〈瓜瓞綿綿〉作品細部（見圖錄G09）
Left : "Prosperous Descendants" detail (see Exhibition Catalogue G09)
攝影／黃送昌　Photograph by Huang Sung-Chan

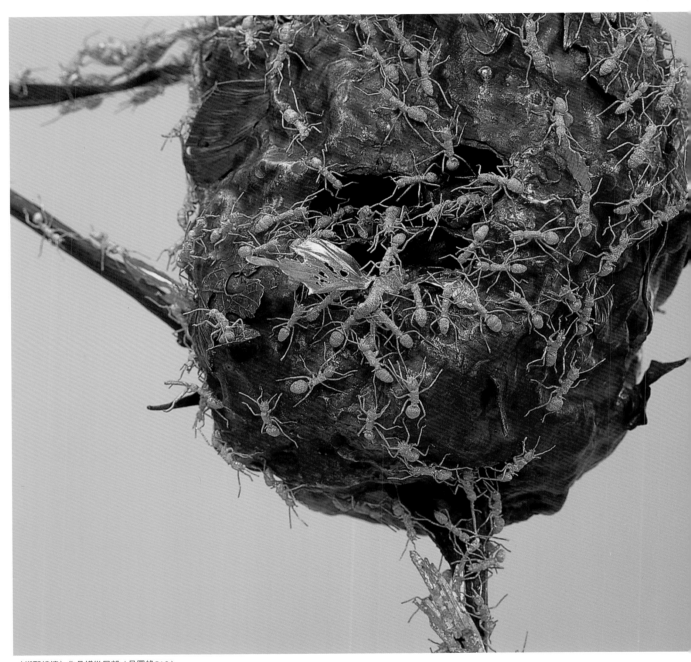

〈鄉野情懷〉作品蟻巢局部（見圖錄G10）
"Reminiscence of Rustic Pleasures" detail of an ants nest (see Exhibition Catalogue G10)

攝影／黃文隆　Photograph by Huang Wen-Long

Truth and Vanity: Without Truth, All is Emptiness

When he was less than twenty, Wu Ching's definition about creativity simply means to walk wherever is untrodden, and to achieve whatever cannot be done. ❸ As he perceived the need to create for the sake of art, truth becomes the only ideal in his quest. Starting to read Heart Sutra and practice Zen Meditation in 1980s, he came to ponder on intrinsic questions about life from a religious perspective and appreciated the symbiosis of nature and human beings. At this stage, he properly reflected his philosophy through his works. Wood carvings such as "Struggle for release," "Zen," "Unhindered," "Dreaming of Butterflies" and the gold works "Man or Butterfly?", "Mundane Affinity," "Eternal Life, Eternal Death," "Intermingling of Grief and Joy," "The Bliss of the Dharma" are good examples. If we can take the religious experiences of the artist into consideration, we can establish a brand new vintage in interpreting his works, what is realistic becomes surrealistic because the artist only borrows the concrete image to elucidate the idea of emptiness.

This exhibition stages a certain phase of Wu Ching's creative life. In the coming few years, he plans to launch another exhibition for his wood carvings in order to present to his spectators an honest record which is closest to the origin of his life. Wu Ching is less than fifty years old. His spiritual Odyssey is but at a mid point, isn't it?

All the notes are exerted from "A Brief Biography of Wu Ching" based upon numerous interviews of artist done by Professor Lin Pao-Yao, Dean of Faculty of Culture Resources, Taipei National University of the Arts, and his graduate student. "A Brief Biography of Wu Ching" was drafted in 2001.

(interviewed and written by Huang Chung)

吳卿簡歷

1973 開始學習木雕民藝

1975 開始研究螞蟻生態

1978 完成第一件木雕螞蟻作品

1979 作品入選全國美展和省美展，開始飼養黑色螞蟻

1980 專心埋首雕刻螞蟻，閱讀〈般若波羅密多心經〉並開始學坐禪

1983 應邀參加台北市立美術館開幕展

1984 獲「第二屆中日美術交流展」招待獎，應邀至日本名古屋刈谷美術館發表「木雕螞蟻個展」，行前於北美館發表國內首次個展

1985 受台北國立科學教育館委託，製作銀、銅材質作品「螞蟻生態」

　　　發表「螞蟻木雕個展」巡迴高雄市及全省各文化中心

　　　蟄居至東湖，全面省思，潛心創作

1986 應邀參展台北故宮博物院現代藝術嘗試展，之後連續十五年在故宮展出不同作品

1988 應邀參展台灣省立美術館開幕展及美國舊金山太平洋博物館之「故宮博物院特展」

1984台視「靈巧的手」
節目介紹吳卿

1984 台北市立美術館首次個展，與母親兄姊合影

1991 台北市立美術館「吳卿金雕展」

Wu Ching: A Brief Biography

1956 Born in Shibei Tsuen, Shingang Shiang, Chiayi (Southern Taiwan)

1973 Began to study woodcarving

1975 Began studying the ecology of ants

1978 Completed his first wood-carving of ants

1979 Works selected for display in the National Fine Arts Exhibition

 Began to keep an ant colony

1980 Concentrated on the carving of ants

 Started reading "Heart Sutra"

 Began to practice Zen meditation

1983 Invited to take part in the Opening Exhibition at Taipei Fine Arts Museum

1984 First Solo Exhibition of wood carving of ants, Taipei Fine Arts Museum

 Awarded a Prize at the China/Japan Fine Arts Exchange Program and invited to give solo exhibition of ant carvings at Kariya Museum of Art, Nagoya, Japan

1985 Completed "The Ecology of Ants," made of bronze and silver (Commissioned by National Science Education Hall)

 Touring solo exhibition of ant carvings in cultural centers throughout Taiwan

 Retreat at Tung-Hu for meditation and reflection for the purpose of composition

1998 美國舊金山

1989　開創黃金雕刻藝術作品

1990　完成「蝴蝶蘭」全株純金作品，全力研發金雕，培養助手

1991　台北市立美術館發表「吳卿金雕展」

1993　台北中影文化城發表「吳卿金雕展」

　　　台北故宮博物院收購「瓜瓞綿綿」金雕作品，為四十年來第一次破例典藏當代藝術家作品

1994　應邀參展文建會策劃「全國文藝季」

1995　應文建會邀請，由新港文教基金會承辦，前往美國紐約發表金雕個展

1997　台北國父紀念館中山畫廊發表「吳卿金雕展」，由國際佛光中華總會主辦，門票收入捐助佛光大學建校基金

1998　台中中友百貨發表「吳卿金雕展」

1999　分別在嘉義文化中心和高雄市立歷史博物館發表「吳卿金雕展」

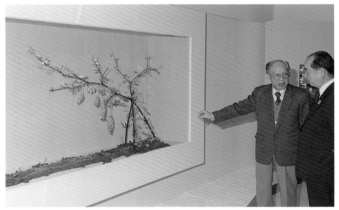

左上：1995 台北故宮博物院展示所典藏的〈瓜瓞綿綿〉作品，
　　　圖中為院長秦孝儀
左下：1996 佛光會星雲法師微觀吳卿的木雕〈禪〉
右上：1998 台中中友百貨發表金雕展

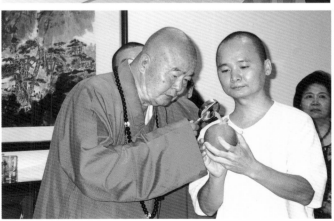

1986 Invited to take part in the Experimental Exhibition of Contemporary Art, National Palace Museum

Beginning this year, exhibited at National Palace Museum for fifteen consecutive years with different works

1988 Invited to take part in the Opening Exhibition at the Taiwan Museum of Art

Invited to take part in the "National Palace Museum Special Exhibition" at the Pacific Museum, Sanfrancisco

1989 Began experiments with gold sculpting

1990 Completed the work "Moth Orchid" made of pure gold

Devoted himself to experiments with gold sculpting

Started to cultivate talented young artists

1991 "Exhibition of Gold Sculptures by Wu Ching," Taipei Fine Arts Museum

1993 "Exhibition of Gold Sculptures by Wu Ching " Chinese Culture and Movie Center

Taipei National Palace Museum purchased "Prosperous Descendants" for its permanent collection, the first purchase of a work by a living artist in forty years

1994 Invited to exhibit at the National Festival of Culture and Art (launched by the Council for Cultural Affairs)

1995 "Exhibition of Gold Sculptures by Wu Ching" in New York (Organized by Council for Cultural Affairs, sponsored by Hsin Kang Foundation of Culture and Education)

1995 New York

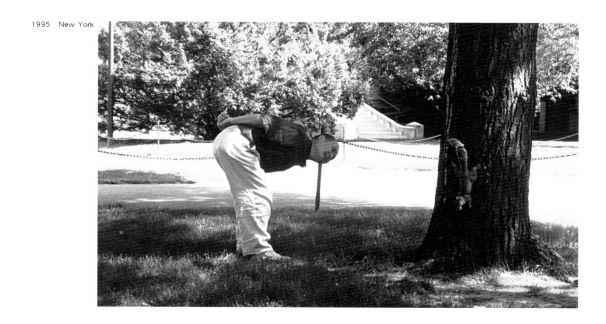

2001　參展「瑞芳黃金傳奇」特展

2002　台中縣文化中心「金玉滿堂」特展

2003　新光三越文化館發表「傳神與焠鍊—吳卿的金雕世界」個展

2004　荷蘭銀行舉辦吳卿梵谷 時空對話，首度發表「法喜」

2006　新港文教基金會「吳卿木雕‧金雕‧裝置與雕塑藝術展」

2006　101大樓89樓觀景台首次個人特展「台灣黃金印象—吳卿金雕藝術展」 （觀景台入場門票350元）

右上：1995 美國紐約金雕個展
右下：2004 荷蘭銀行展覽邀請林保堯教授講解
左下：2006 新港文教基金會展覽

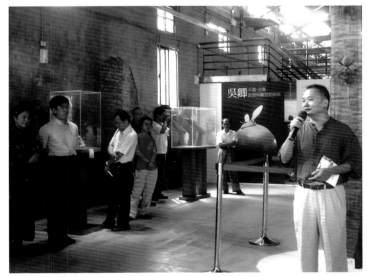

1997 "Exhibition of Gold Sculptures by Wu Ching" at Dr. Sun Yat-sen Memorial Hall in Taipei (sponsored by the ROC headquarters of the Buddha's Light International Association, proceeds from the Exhibition were donated to the fund for the founding of Fo Guang University)

1998 "Exhibition of Gold Sculptures by Wu Ching" at Chung Yo Department Store, Taichung

1999 "Exhibition of Gold Sculptures by Wu Ching" at Chiayi Cultural Center

 "Exhibition of Gold Sculptures by Wu Ching" at Kaoshiung Museum of History

2001 Special Exhibition at "The Rueifang Legend of Gold"

2002 Consortium Exhibition "A Houseful of Splendor and Magnificence" at Taichung Cultural Center

2003 "Extracting the Refined, Imparting the Spirit: The World of Wu Ching's Gold Sculptures" Solo Exhibition at Shin Kong Mitsukoshi Cultural Hall

2004 ABN AMRO hosted 'Timeless Speech Between Wu-Chin and Van Gogh', and 'Joy of Worship' was first introduced.

2006 Hsing-Kang Foundation of Culture and Education hosted 'Wu-Chin's Wood-Engraving, Gold-Engraving, and Display and Sculpture Exhibition'

2006 First personal special exhibition, 'Taiwan Gold Impression – Wu-Chin's Gold-Engraving Exhibition', was held at the observation deck on the 89th floor of Taipei 101. (Admission Ticket of NT350)

2006 101大樓觀景台
首次個人特展

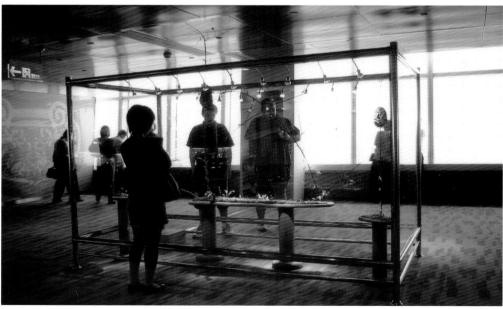

2007　參與宜蘭國立傳統藝術中心第一季的〈金屬工藝特展〉、第二季的〈竹藝特展〉、第三季的〈木雕特展〉

2008　吳卿接下國立台灣傳統藝術總處籌備處的96年度傳統藝術文物特約製作暨傳習計畫，帶領１０位「藝生」製
　　　作)「鄉野情懷」系列金雕鉅作，時間長達16個月(作品全長6公尺、寬4.2公尺、高4.2公尺)。

國家特約典藏金雕鉅作

台灣當代金雕藝術大師-吳卿的作品「鄉情」，是行政院文建會
傳統藝術總處籌備處、國立傳統藝術中心首位特約典藏的曠世
金雕鉅作暨傳習計畫，這不僅是台灣推動國家特約典藏政策的
創舉，同時不論是作品規模、技術工法和藝術成就，都是傳藝
中心唯一的大型藝術創作委託案。

上:2008春 傳習所一所拆遷作業

上:2007春天 運送到傳統國立藝術中心傳習一所(作品主架構底做與竹枝)

中:2007夏末 傳習一所，第一次安裝金雕鉅作黃金 吳老師與藝生

中:2008春 吳老師進行 拆遷至國立傳統藝術中心展示館二樓

下:2008春 傳習所一所丈量作品尺寸,進行拆遷作業

下:2008夏　展示館二樓，吳老師講解組裝作業流程工作圖

2007 Wu Ching was invited to join the events of The National Center for Traditional Arts in Ilan: the first quarter "Metal Craft Exhibition", the second quarter "Bamboo Craft Exhibition", the third quarter "Wood Carving Exhibition".

2008 Wu Ching took the project "The special annual production and heritage of traditional arts 2007"of the Preparatory Office of the National Headquarters of Taiwan Traditional Arts. He led 10 arts students to make "Reminiscences of Rustic Pleasures" series of giant gold sculptures(6 meters long、4.2 meters wide and 4.2 meters high) for up to 16 months.

National special collection of a large-scale gold sculpture

The work 'Rustic Feelings' by Wu Ching, who is Taiwan's contemporary master of gold sculptures, is the first piece of excellent gold work specially that was made during the Program of Teaching-learning, organized by the Preparatory Office of the National Headquarters of Taiwan Traditional Arts, Council for Cultural Affairs, Executive Yuan, and the National Center for Traditional Arts, and collected by the Center. It is not only a pioneering policy of the promotion of the national special collection but it is also the only large-scale commission of artwork for the Center for Traditional Arts in terms of the work's size, craftsmanship and artistic value.

2008夏 國立傳統藝術中心鄉野情懷(完成品)吳老師與作品合照

上:2008夏　展示館二樓，進行組裝調整金雕鉅工作圖

下:2008夏　展示館二樓，進行最後金雕鉅作調整工作

2009　台北101大樓89樓觀景台再度邀請特展「台灣黃金印象─吳卿金雕藝術展」
2010　吳卿接受上海中國航海博物館的邀請,純金打造春秋戰船,位於中國航海博物館再現古船文化(三公斤打造)

上:2011春 地點:位於中國航海博物館展出
地　址：上海市浦东新区临港新城申港大道197号

中國航海博物館

典藏記憶：二千多年前的「東吳大翼戰船」，曾經見證了吳越春秋歷史的興衰；如今將藉由純金打造、實體再現的金雕創作，重新展現了水戰交烽中的英姿榮耀。位於今天江蘇的小國吳國，憑著性能優異的戰船、訓練精良的水師，在迅速竄起後繼而北伐稱霸，影響了春秋末期的政局。其中的主力戰船之一，便是這件大翼戰船，為了重新顯影這段歷史記憶，金雕藝術大師吳卿特別企劃精心製作，透過亙古不變的黃金材質，以做為後世追憶歷史的永久典藏。

中:2011春 地點:位於中國航海博物館展出

檢閱戰船：根據文獻記載，戰船總長12丈、寬1丈6尺，搭乘官兵共計98人，戰士位於船艙上方含指揮官1、瞭望兵2、鼓手1，與甲板上作業之水兵40，共計44人，另外1人在於船艙下層位於船艙下方的單舷十二槳，每支兩人，面向交錯對戰士作戰；另外一名則經由鼓聲，控制船艙下的划槳速度。至於甲板上方的戰士，就是水戰交鋒的戰鬥部隊，分別手持鉤、矛或斧等兵器，或是拉弓向敵方射箭。從這件金雕作品的表現中，彷彿又回到了二千多年前，在船上激烈交戰的悲壯畫面。

下:展出地點特寫

金雕鉅作：本件金雕東吳大翼戰船，全長43公分、寬13公分、高17公分，是原船的百分之一。即使在這麼小的尺寸之中，前述所言及的細節，仍然絲毫一一具現，而且人物表情、肢體動態都是栩栩如生。這種追求紀實和真實的態度，是以精緻雕刻出身的吳卿，對藝術創作的一貫堅持。至於本件金雕戰船的完成，是吳卿繼台北國立故宮典藏的「瓜瓞綿綿」、國立傳統藝術中心的「鄉情」之後，又一件奠下後世金雕歷史典藏的鉅作。

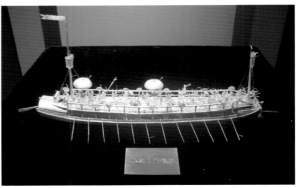

Collecting Memories

Two millennia ago, the Golden "big wing" warship of the Eastern Wu stood testimony to the waxing and waning fortunes of the kingdoms of Wu and Yue. Today, the ship rides the waves again, this time crafted from solid gold, in a vivid re-creation of the pitched battles of yore. The tiny kingdom of Wu, located in modern-day Jiangsu Province, relied on high-performance warships and finely trained sailors to quickly win local dominance before going on to conquer a bigger neighbor in the north. Though small, the kingdom decisively affected the balance of power among the kingdoms of the latter Spring and Autumn Period. The ship you see here is a reproduction of one of the Wu kingdom's main warships. To recreate the zeitgeist of that period in history, noted gold sculptor Wu Ching accepted a commission to craft a scaled-down Wu warship from solid gold, to be treasured forever by future collectors.

2009 Special exhibition 'Taiwan's Impression of Gold — Wu Ching's exhibition of gold sculptures' invited again by the 89th Floor Viewing Platform, Taipei 101.

2010 Wu Ching was invited by the China Maritime Museum, Shanghai, to make a pure gold warship of the Spring and Autumn Period and this work is displayed at the Division of Representation of Ancient Ship Culture, China Maritime Museum (made from 3kg of gold)

作品完成圖

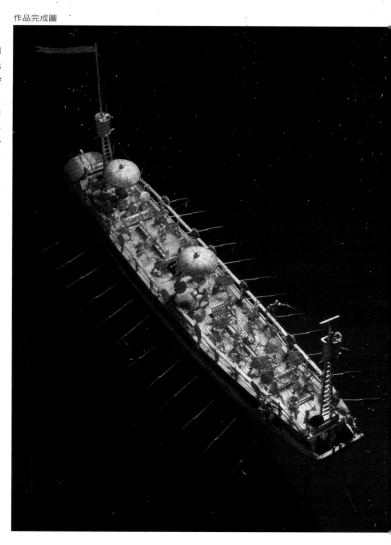

Description of the ship

Historical records indicate that the original ship measured roughly 43 meters long and 13 meters wide, and carried 98 officers and soldiers. In this sculpture, the top-deck crew of 44 includes a commander, two lookouts, one helmsman, and 40 oarsmen. In the meantime, a messenger is running about on the lower deck, where there are another 48 oarsmen (seated opposite each other in pairs, two men per oar, with 12 oars on both side of the ship), plus one person manning the stern, one manning the bow, one person moving about, and two more men climbing the stairs. The rowers' positions are protected by an outer cladding. There is a helmsman at both bow and stern to control the ship's direction, and a commander both fore and aft standing above deck beneath a canopy. In addition, another person beats drum to control the pace at which the oarsmen row. The job of the fighters on the top deck is to engage the enemy, which they do using hooks, spears, hatchets, and other weaponry, including bows and arrows. This gold sculpture takes us back to an epic battle that took place over 2,000 years ago.

Tremendous work of gold sculpture

This "big wing" gold warship measures 43cm long x 13cm wide x 17cm high, and is a 1:100 scale model replica of the original craft. Despite the replica's small size, the features described above are executed in exquisite detail. The facial expressions of the sailors, and their body movements, are uncannily lifelike. The realism of this sculpture is the spirit that has always marked the work of Wu Ching, who has previously been commissioned to do tremendous works for the Taipei National Palace Museum ("Prosperous Descendants") and the National Center for Traditional Art ("Reminiscences of Rustic Pleasures").

2011　　西安世園會邀請吳卿於長安塔的第四、第五層展出29件金雕,內含5件大尺寸的巨作。

吳卿老師受邀陝西省省長趙正永前往西安研討參加
「2011西安世界園藝博覽會展出」事宜

西安世界園藝博覽會

經過五年的籌劃與施工,「西安世界園藝博覽會」於2011年04月28日至2011年10月22日終於在西安展出。

西安世園會,也是西安千年以來第一次舉辦的博覽會,吳卿應邀參與此次的盛會,他表示備感榮幸。開幕前夕,著名國學大師文懷沙手書「技近乎道」四字相贈,以褒揚吳卿精湛的雕刻藝術。

尤其是趙正永省長與王軍書記,親自帶領大陸中央部會與各省重要幹部到金雕會場參觀,深入了解作品的特色,更顯得意義非凡。

178 天的展期,入園遊客人數約有1,572 萬人,創下歷屆世園會之最。其中,至長安塔參觀者逾160萬人。因長安塔僅能容納 9,000 人同時參觀,許多人必須排隊3、4 個小時等候進場。長安塔是西安世園會的核心場區,除了吳卿的金雕展,也展出大陸國寶-車銅馬及「彩色兵馬俑」,為何許多民眾寧可花時間排隊看金雕作品?

西安書記王軍稱許:「吳卿先生的金雕作品,極富特色,這次在西安世界園藝會展出,十分轟動,更受到海內外觀眾的好評。」

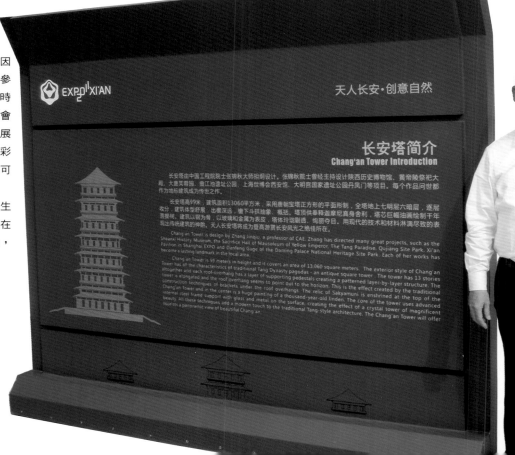

2011 Wu Ching was invited to participate in the " International Horticultural Expo. 2011 Xi'an" to show 29 gold sculptures on exhibition rooms at the fourth, fifth floor of the Chang' an Tower. Five large-sized masterpiece sculptures were included.

媒體盛讚：「吳卿的金雕，雕工精美、出神入化，藝術價值極高；更重要的是他的作品充滿了中國文化的情懷，包括宗教意識、人文情懷等等，藝術表現和他的人格特質緊密結合，已到達登峰造極的水平。」

上:2011西安世界園藝博覽會，四大標誌性建築 長安塔(其內展品都是重要一級國寶，一級文物)

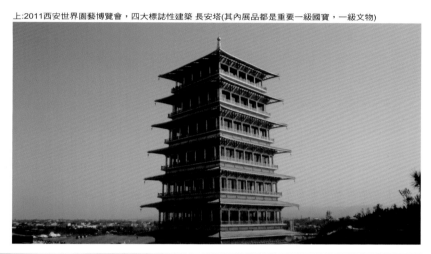

下:與西安書記－王軍 書記討論「2011西安世界園藝博覽會展出」事項

After five years of planning and construction,

"International Horticultural Exposition 2011 Xi'an" was finally exhibited in Xi'an on April 28 to October 22, 2011.

"International Horticultural Expo.2011 Xi'an", was the first exposition held in Xi'an during thousand years. Wu Ching was invited to participate in this event, and he felt greatly honored. Before the opening, Wen Huai-sha, the Master of Chinese literature in China, wrote "Skills integrate Taoism" as a gift to praise Wu Ching's exquisite sculptures.

Xi'an Governor Zhao Zheng-yong and Wang Jun, governor of particular secretary, personally led many important cadres of the mainland provinces and central ministries to visit the venue of gold sculptures, in-depth understanding of the characteristics of work. This was more meaningful.

During178 days of the exhibition, there were about 15.72 million visitors, a record of most successive International expositions. More than 1.6 million people had visited the Chang' an Tower. For a long while the
Chang' an Tower only accommodated 9,000 people to visit, many people had to line up three or four hours waiting for admission.

The Chang' an Tower was the core area of "International Horticultural Expo.2011 Xi'an". In addition to Wu Ching's exhibition, national treasures of China "Vehicle Bronze Horse" and "Color Warriors" were exhibited at the same time. Why did many people prefer to spend time queuing to see Wu's gold sculptures?

Wang Jun, secretary of Xi'an praised: "The gold sculptures of Mr. Wu Ching are so unique and full of features. His works are warmly welcomed and appreciated by all the audience from every place."

Media complimented:" Wu Ching's gold sculptures are so exquisite, beautiful and full of high artistic value. More importantly, his works are full of feelings of Chinese culture, including religious consciousness, human feelings, etc. His sense of artistic expression is closely combined with his personalities, and the level of his work has reached its peak."

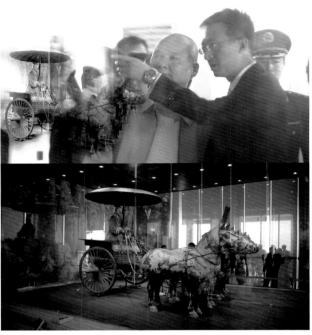

上：【國寶－銅車馬】
在這裡是無法與「國寶－銅車馬」拍照，但館長特別同意我們能在長安塔內攝影記錄這一切。
台灣的國寶「吳卿大師」與中國的國寶「銅車馬」合照。留下了這有畫面、珍貴的歷史記錄。

下：西安世界園藝博覽會展覽期間178天入園遊客人數有1,572萬人，創下歷屆世園會之最。至長安塔參觀逾160萬人，因至長安塔一天僅能容納9,000人，每日需排隊3、4個小時才能進長安塔。

上：位於長安塔，五大金雕作品暗層(位於四層)

中：位於長安塔，遊客參觀金雕作品明層(五層)

下：位於長安塔，遊客參觀金雕作品明層(五層)

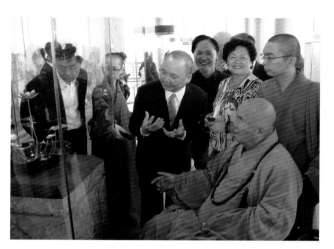

上下：星雲法師蒞臨參觀賞，長安所展出的吳卿(五大金雕作品)與專訪報導

展出作品圖錄

W01

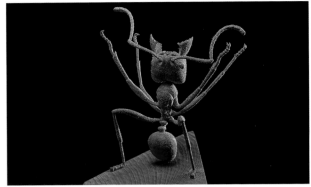

蠱吼
Soar and Roar

黃楊木
Boxwood
1978
9×10×24cm
創作之意念。
Ideas of creation.

W02

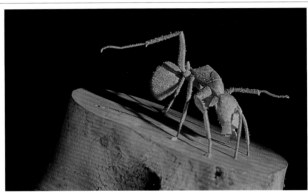

抽（三）
Withdraw

黃楊木
Boxwood
1981
13×13×13.5cm
抽象意念的表達。
The expression of abstract ideas.

W03

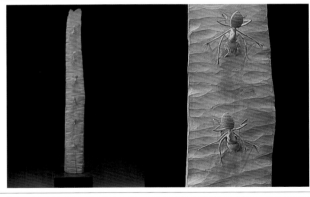

掙脫（大）
Struggling for Release

檜木
Juniper
1984
31×31×380cm
擺脫自我的限制。
Breakout from self-limitation.

W04

穿梭
Shuttle

黃楊木
Boxwood
1986
66×5×77cm
抽象的表達螞蟻在穿梭時空。
Abstract expression of ants traveling in time and space.

W05

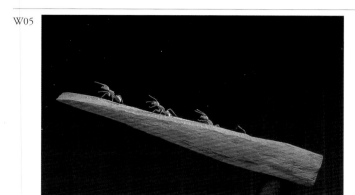

生命的過程
Course of Life

石斑木（又稱狗骨木）
Rhaphiolepis indica
1983
86×13×59cm

露出了希望的觸鬚，掙脫了環境的限制。
Exposing the antennae for hope,
they straggle hard from environmental constraints.

W06

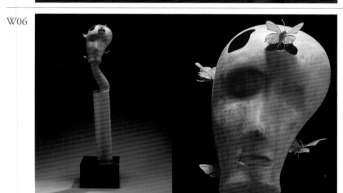

夢蝶
Dreaming of Butterflies

黃楊木
Boxwood
1988
23×23×100cm

憶起蝴蝶時，就飛入飛出想像中。
Flying in and out of fantasy while recalling butterflies.

W07

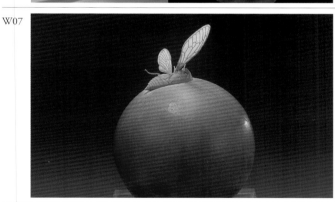

禪
Zen

黃楊木
Boxwood
1986
50×12×16cm

"在圓體上雕有半隻蟬，而另一半呢？
是在圓體內？是出世？是入世？是圓體？是蟬？是禪，本無分別的。
On a round object, half a cicada. What of the other half?
In the ? Out of the world? In the world? Is it the object?
Is it the cicada? It is Zen, the essentially indistinguishable.

W08

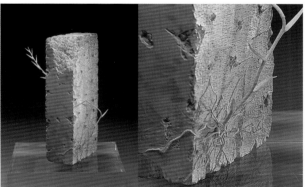

無礙
Unhindered

黃楊木
Boxwood
1987
90×20×20cm

"磚塊是堅硬的實體，猶如個人對事物的執著，小草是我們的心念，
穿過堅硬的磚塊，表面沒有裂縫，磚塊有沒有實體存在呢？意識限
制了自我，自在就沒有限制。

The brick is solid, as hardheaded as any person in daily affairs; the plant represents
our ideas and thoughts, breaking through the hand brick. On the surface there are no
cracks. But does the brick really have a substantive existence? It is conscious thought
that hinders us; at our most natural we are without limitations."

G01

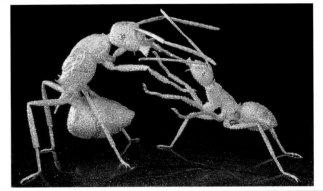

親情（大）

Parental Love

純金60公克、瑪瑙
Pure gold 60g, agate
1989
10×7×10cm
孕育創作的泉源。
Cherishing the fountainhead of creation.

G02

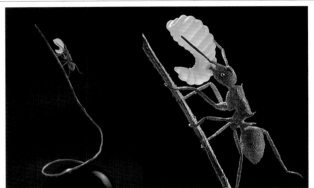

護幼

Protecting the Young

純金60公克、瑪瑙
Pure gold 60g, agate
1990
13×9×23cm
自然生態中的真情。
Genuine affection in the natural world.

G03

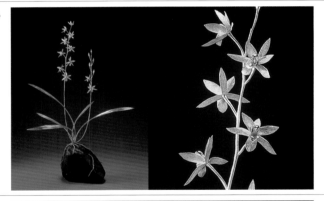

報歲蘭（大）

New Year's Orchid

純金1150公克、石
Pure gold 1150g, Stone
1991
55×26×87cm
是舊歲，是新年，是結束，是開始。
Old year, new year; an end, a beginning.

G04

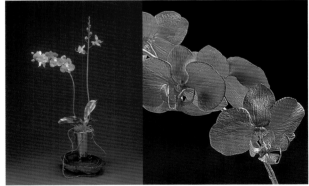

蝴蝶蘭

Moth Orchid

純金5600公克
Pure gold 5600g
1990
40×36×102cm
給他多少愛，它就有多少的情。
Love given equals love received.

G05

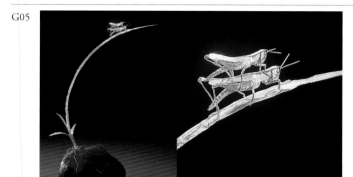

風吹草動
Rustle of Grass in the Wind

純金225公克、石
Pure gold 225g, stone
1991
30×12×42cm

細細的鳴叫聲，
是生命延續的開始。
A thin chirping sound
marks the continuation of life.

G06

蝶之愛
Love of Butterflies

純金50公克、銀
Pure gold 50g, silver
1995
12×10×13cm

大自然生命延續的微妙。
The mystery of life's perpetuation.

G07

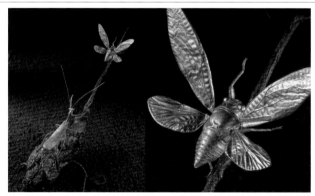

螳螂捕蟬
Mantis Capturing a Cicada

純金77公克、銀
Pure gold 77g, silver
1995
30×15×15cm

讓牠重回大自然的懷抱。
Returning it to the embrace of nature.

G08

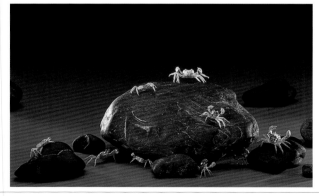

戲水
Water Frolic

純金298公克、石
Pure gold 298g, stone
1991
56×40×12cm

難以忘懷的回憶。
An unforgettable memory.

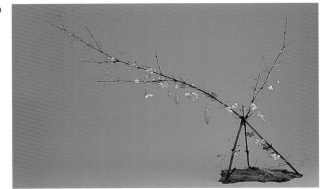

瓜瓞綿綿（大）
Prosperous Descendants

純金2900公克、銀、銅
Pure gold 2900g, silver, bronze
1995
195×105×133cm

對童年景物的戀情。
Fond memories of my childhood world.

G09

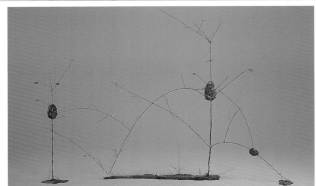

鄉野情懷（加大）
Reminiscences of Rustic Pleasures

純金2000公克、銀、銅
Pure gold 2000g, silver, bronze
1996～2003
683×140×356cm

自然界的社會群體。
Social organization in the natural world.

G10

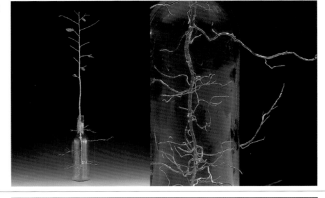

我需要泥土（大）
I Need Soil

純金150公克、玻璃
Pure gold 150g , glass
1992
20×20×70cm

生存有淨土，生命能昇華。
Where there is pure land, life will flourish.

G11

我需要水
I Need Water

純金65公克
Pure gold 65g
1995
47×5×20cm

雖然我的身體不存在了，
我還要乾淨的水。
Though my body does not exist, I still need clean water.

G12

G13
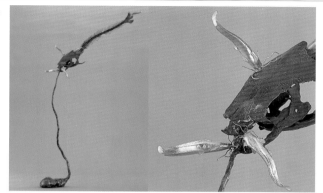

母與子
Mother and Son

純金42公克、銀
Pure gold 42g, silver
1995
30×12×55cm

生生世世牽連的親情。
Familial feelings link from generation to generation.

G14
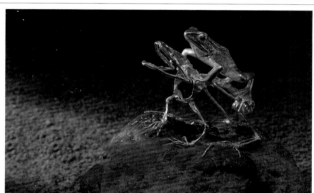

生死之戀
A Love of Life and Death

純金115公克、石
Pure gold 115g, stone
1995
14×12×14cm

已經是不同生死空間了，還那麼的戀戀不捨。
Though in another realm of life and death,
we are still in love.

G15
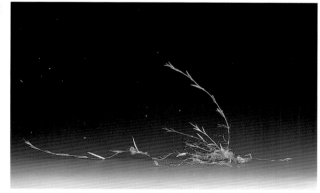

我的生命
My Life

純金180公克、塑膠
Pure gold 180g plastic
1995
70×30×24cm

雖然我的生命旺盛，
但是，
我想要美好的生活品質。
Although my vitality is strong,
I also want better quality of life.

G16
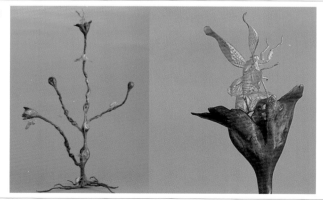

生之源
Fount of Life

純金110公克、銀
Pure gold 110g, silver
1995
41×30×62cm

長年的暗藏，
短暫的喜鳴。
So many years in darkness,
I enjoy the brief moment of happiness.

G17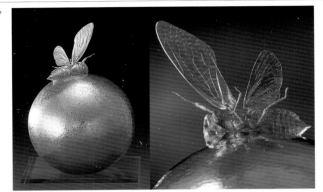

禪
Zen

純金65公克、銀
Pure gold 65g, silver
1991
14×14×21cm

"在圓體上雕有半隻蟬,而另一半呢?是在圓體內?是出世?是入世?是圓體?是蟬?是禪,本無分別的。
On a round object, half a cicada. What of the other half? In the ? Out of the world? In the world? Is it the object? Is it the cicada? It is Zen, the essentially indistinguishable.

G18

無礙
Unhindered

純金25公克、銀
Pure gold 25g, silver
1991
16×9×20cm

"磚塊是堅硬的實體,猶如個人對事物的執著,小草是我們的心念,穿過堅硬的磚塊,表面沒有裂縫,磚塊有沒有實體存在呢?意識限制了自我,自在就沒有限制。

The brick is solid, as hardheaded as any person in daily affairs; the plant represents our ideas and thoughts, breaking through the hand brick. On the surface there are no cracks. But does the brick really have a substantive existence? It is conscious thought that hinders us; at our most natural we are without limitations."

G19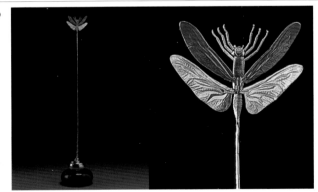

昇華
Sublimation

純金300公克
Pure gold 300g
1990
8×6×59cm

圓球母體孕育著新的生命,懷抱新的希望,螺旋轉動漸漸升起,衝上自我超脫的境界。
A round maternal body incubates a new life, new hope; swirling upward, aspiring to a transcendent state.

G20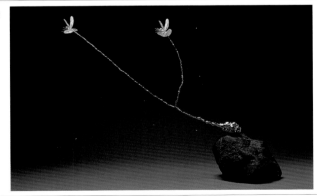

比翼雙飛
Fly Wing to wing

純金260公克
Pure gold 260g
1990
50×9×30cm

印象中的比翼雙飛,自由、浪漫、唯美地悠遊於空中,而現在的比翼雙飛,多了一個包袱。
The flying pair appears free, romantic, cavorting in space; but now they have a sweet burden.

G21

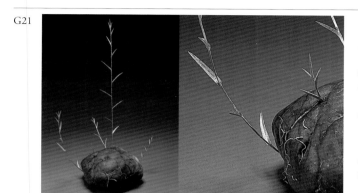

隨緣自在
Liberation

純金150公克、石
Pure gold 150g, stone
1991
42×28×56cm

萬年的石頭，萬年的不變，柔軟的小草，穿過那不變的執著，
是無所限制、隨緣自在的。
Ancient stone never changes and has been the same. Soft
grass breaks through it freely and without restrictions.

G22

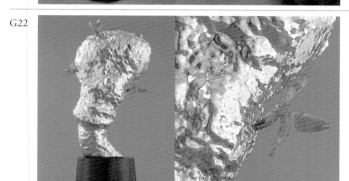

是人？是蝶？
Man or Butterfly?

純金150公克、銀
Pure gold 150g, silver
1991
29×29×55cm

禪坐時，意念起蝴蝶飛入、飛出想像之中，到底是人？還是蝴蝶呢？
Butterflies flying in and out of the imagination during Zen
meditation. Man? Or butterfly?

G23

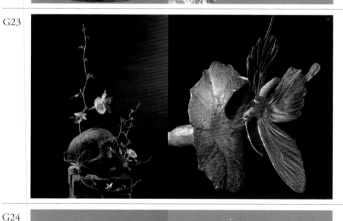

塵緣
Mundane Affinity

純金510公克、銀
Pure gold 510g, silver
1995
40×32×57cm

萬年的石頭石化了，還執著不化，纏繞著滿頭的牽牛花，
是情？是愛？意念是種子，萌芽…….開花……結果……。
Ancient head petrified, refusing to change;
the morning glory surrounds it. Is it sentiment? Love?
Thoughts are seeds that sprout, blossom, and give fruit.

G24

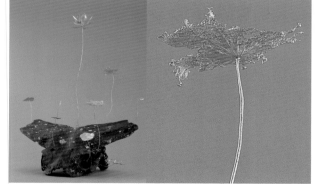

緣生妙有
Mystery of Life

純金435公克、化石
Pure gold 435g, petrified wood
1995
60×35×70cm

萬年前，我是心地充滿善念的一頭牛，
萬年後，善念的種子開花結果了。
Millennia ago, I was a bull with no ill intentions;
millennia later, my good nature is now blossoming.

G25

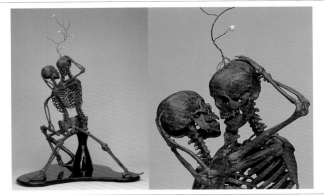

情為何物？

What is Love?

純金76公克、銅
Pure gold 76g, bronze
1996
140×132×194cm

男:我們現在擁吻好看嗎?
女:那為什麼我們還在流淚呢?
情愛不是永恆的存在嗎?
Man: Don't we look good whan we are kissing and hugging?
Woman: Then why are we crying?
Is love forever?

G26

心動

Throb

純金150公克、銀
Pure gold 150g, silver
1996
220×47×20cm

是草動嗎?是磚動嗎?不是草動,不是磚動,仁者心動。
Is the grass moving? or the brick moving?
Neither; it is the benevolent heart.

G27

花呢？

And the Flower?

銀
Silver
1996
23×16×26cm

本來空無一物,何來手與花呢?
At first there is nothing;
from whence the hand and the flower?

G28

緣生緣滅

Eternal Life, Eternal Death

銅
Bronze
1996
17×20×22cm

存在只是因緣聚合,
死了只是形體不存在而已。
Existence is a conjunction of circumstance;
death is but the absence of the body.

G29

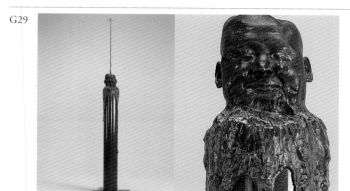

悲喜交集
Intermingling Grief and Joy

純金120公克、銅
Pure gold 120g, bronze
1996
96×71×275cm

連續幾天的禪坐，睜開眼睛時，剎那間，契入宇宙萬物都是空的，
所有萬象都是不實在的，良久…… 良久……，感受那執著的苦，
眼眶不由自主的而出盈眶而出，內心充滿悲憫與歡喜。

*After several days of Zen Meditation, I suddenly realized that everything in
the universe is empty. Things are not real. When I opened my eyes, tears
began to flow and my heart was full of sadness and joy at the same time.*

G30

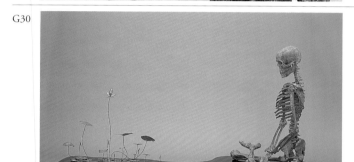

禪，坐？
Zen, Meditation?

純金64公克、銅
Pure gold 64g, bronze
1996
184×80×94cm

纏不是坐，坐不是禪，青蛙不是也在坐禪嗎？
Zen is not meditation, meditation is not Zen;
is not the frog also doing Zen meditation?

G31

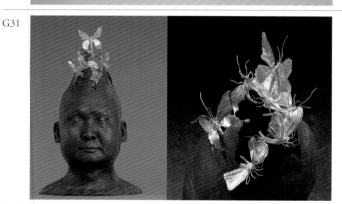

法喜
The Bliss of the Dharma

純金196公克、銅
Pure gold 196g, bronze
1996
26×22×48cm

悟入寧靜中的法喜。
Comprehending Buddhist joy through quiescence.

G32

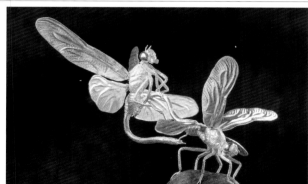

蜻蜓之愛
Love of Dragonflies

純金36公克、石
Pure gold 36g, stone
1993
13×9×13cm

G33

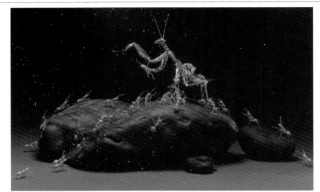

螳螂與螞蟻
Mantis and Ants

純金1050公克、石
Pure gold 1050g, stone
1990
63×32×33cm
大自然現象的縮影。
Microscopy of nature.

G34

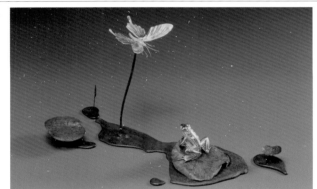

鳳蝶戲神蛙
Butterfly making fun of frog

純金81公克、銅
Pure gold 81g, bronze
1999
30×17×17cm
動靜之中。
Moving and Calm.

G35

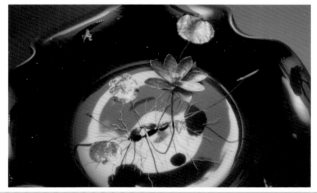

荷生妙有
Magical Lotus

純金64.54公克、陶
Pure gold 64.54g, pottery
2006
30×30×20cm
無、有、在於心。
Everything Up to Your Heart.

G36

聚寶
Treasure Ball

純金26.25公克、陶
Pure gold 26.25g, pottery
2006
30×30×20cm
用團結來儲存寶藏，
用和諧來成就圓滿。
Perfect World
Cohesion makes treasure
Harmony leads to perfection.

感　　謝

很慶幸地能順利完成這一系列的金雕作品，

製作金雕作品集，

十分感謝父母賜給我一雙靈巧的手，

對事物敏銳的洞察力，

並衷心的感謝所有支持與幫助我的朋友們及工作夥伴們。

這一整批金雕作品若能規劃成立一座「金雕美術館」，

集結金雕之精華，

不只是黃金、藝術史上一大盛事，

更是人類共同文化資產的傳承與延續。

Letter of Thanks

I am grateful that I could complete this series of gold-sculpturing works and put out a portfolio of gold-sculpturing works. I am grateful that my parents have given me manual dexterity and acute perspicacity. I also like to thank all supportive friends and partners. If a museum of gold sculpture can be planned and established to care and display the whole batch of works, it will not only be a celebrated landmark for the art history of gold sculpturing, but will also play a key role in passing down the cultural heritage that can be shared by all humans.

Wu Ching

國家圖書館出版品預行編目資料

佛光山佛陀紀念館・金雕細琢・吳卿雕刻展 / 吳卿 作

Fo Guang Shan Buddha Memorial Center. Works in Gold- Exhibition of Gold Sculptures by Wu Ching

— 二版 — 台北市：吳卿工作室 2011.12

中英對照

ISBN 978-986-83021-1-2（平裝附數位影音光碟）

1.金屬物雕刻—作品集

935.1 100027807

佛光山佛陀紀念館・金雕細琢・吳卿雕刻展

作　　者	吳卿
監　　製	吳明威、吳正標
策劃監督	吳明威、陳育茹、陳麗玉
文字編輯	黃涓、蕭容慧
美術編輯	李韻倩、吳明威
視覺設計	奇藝果創意設計、吳明威
攝　　影	林日山、黃送昌、黃文隆、卓傑
英文翻譯	林素碧、梅德威
顧　　問	陳碧鈴、趙翠慧、卓傑、陳寶珠、蕭容慧

出 版 者	吳卿工作室
地　　址	台北市內湖郵政信箱9-54號
電　　話	(02)26320074　傳　真　(02)26323804
網　　址	www.wuching.com.tw
出版日期	中華民國一百年十二月二版
價　　格	800元